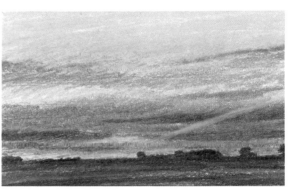

'The landscape is important, more
important than anything else.'

JOAN MIRÓ (1893–1983)

Drawing
Landscapes

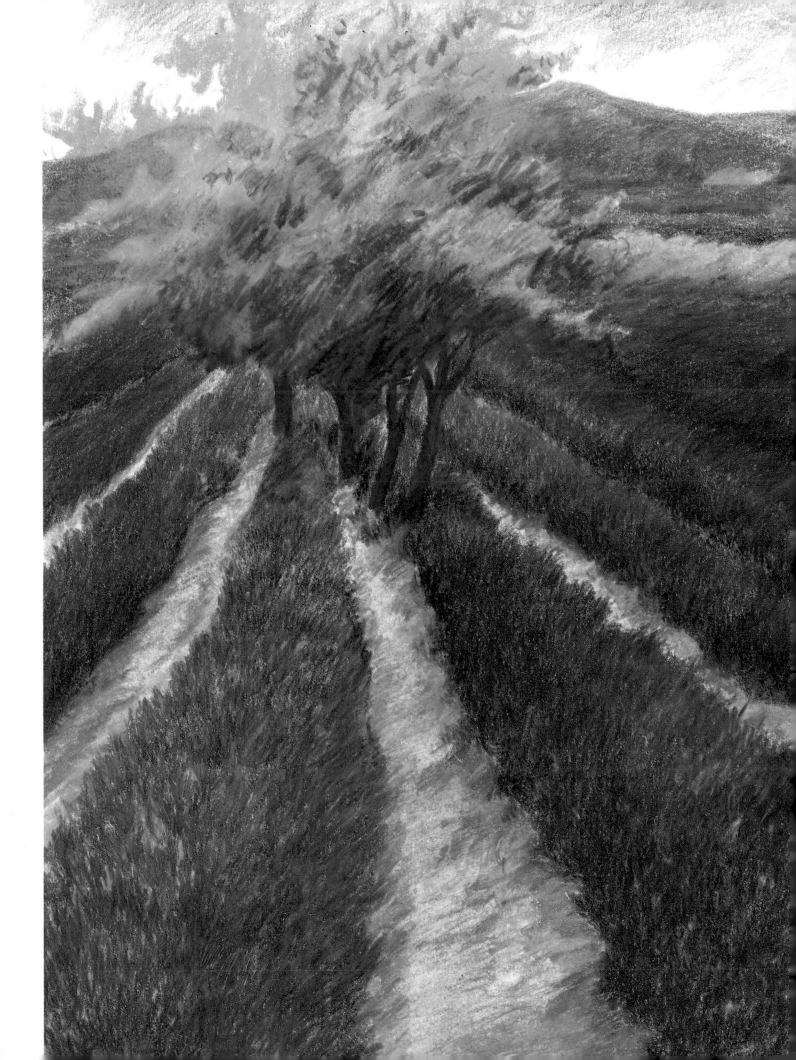

Drawing
Landscapes

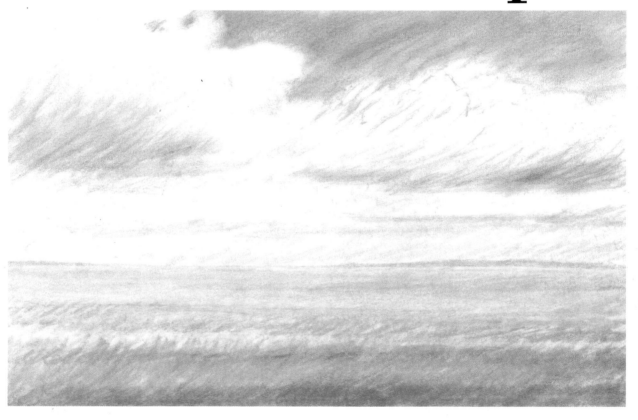

MELVYN PETTERSON

with IAN KEAREY

David & Charles

A DAVID & CHARLES BOOK

First published in the UK in 2002

A catalogue record for this book is available from the
British Library.

ISBN 0 7153 1250 2 (hardback)
ISBN 0 7153 1452 1 (paperback)

Printed in Singapore by KHL Printing Co Pte Ltd
for David & Charles
Brunel House Newton Abbot Devon

Commissioning Editor Sarah Hoggett
Art Editor Sue Cleave
Senior Editor Freya Dangerfield
Production Controller Kelly Smith

Photography George Taylor
Page Layout Visual Image

Picture Captions
Page 1 Sunset in pastels
Page 2 Lavender field in watercolour pencils
Page 3 Prairie view in pastel pencils
Page 5 Shadows in hot sun in wax crayons

*Photograph on page 96(top) George Taylor; pages 102(top rt),
108(top) Sarah Hoggett; page 114(top) Les Meehan*

Contents

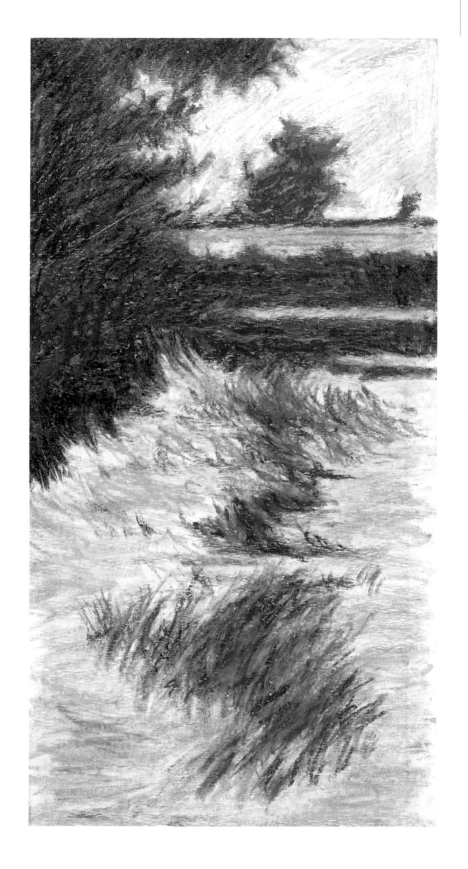

Introduction

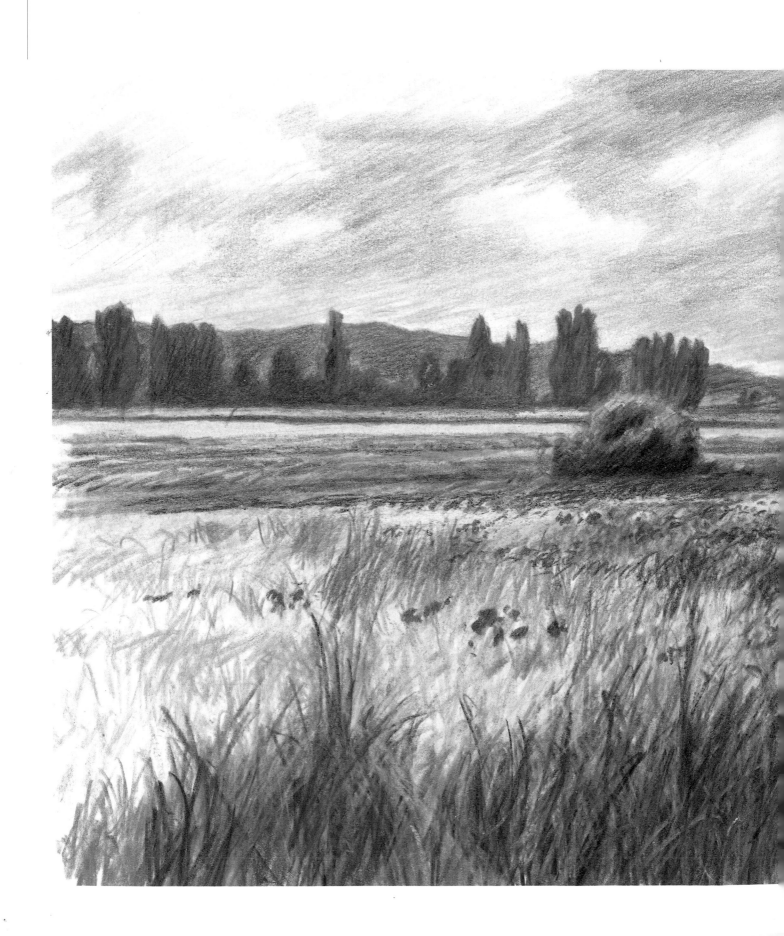

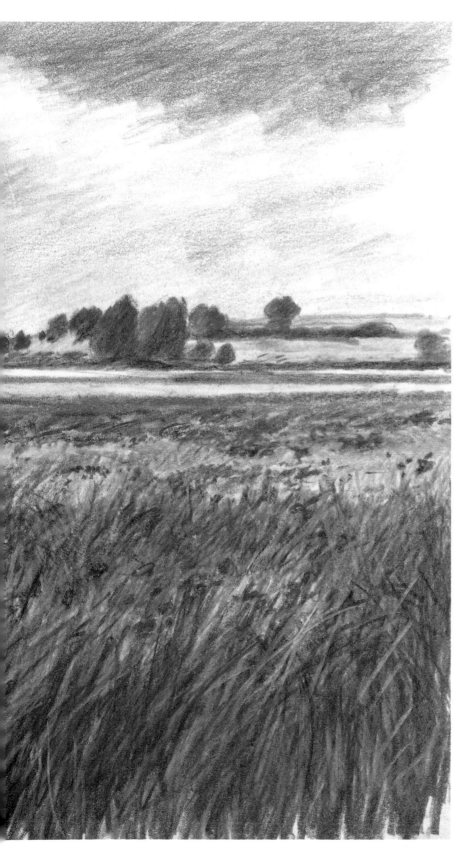

In a way, drawing landscapes gives you the best of all art situations: to start with, there is the still-life quality of the features of the landscape – trees, buildings, hills, fields and so on – plus the movement of clouds, water, animals, birds and people; and of course, you have the ever-changing quality of the light, casting shadows, reflecting and sparkling, or giving a misty, elusive evanescence to the whole scene. In addition, you have the freedom to choose the viewpoint from as many places as you can stand and turn your head to look.

This book aims to be as much about inspiration and encouragement as it is about instruction. The step-by-step exercises and projects are designed to be a springboard for your own work, and to provide the information about what was used and how, without tying you down to a rigid framework. To that end, it is hoped that even the quickest sketches shown here can give you food for thought.

Although the emphasis is necessarily on working on location – finding the right viewpoint, capturing fleeting effects quickly, which media are best to use out of doors – don't forget that a great deal of *plein air* work is about making studies for subsequent drawings. Renoir summed up perfectly the balance that can be achieved: '... a painting is meant to be looked at inside a house, so a little work must be done in the studio, in addition to what one has done out-of-doors. You should get away from the intoxication of real light and digest your impression in the reduced light of a room. Then you can get drunk on sunshine again.'

It is our hope that this book will help you enjoy the 'intoxication' of drawing landscapes.

FRENCH LANDSCAPE IN WATERCOLOUR

PENCILS The lush greens and deep blues of this Italian landscape in summer, punctuated by bright poppies bathed in sunshine, perfectly encapsulates the joy of drawing landscapes.

'*I think I'm painting a picture of two women,*
but it may turn out to be a landscape.'

WILLEM DE KOONING (1904–1993)

Composition

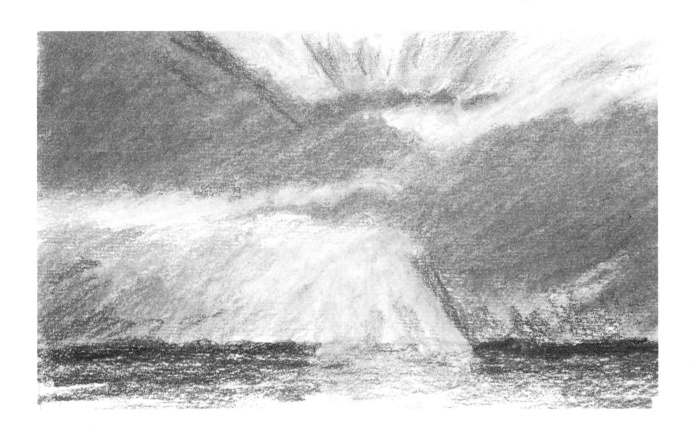

Establishing a focal point

A successful composition hinges on capturing the viewer's interest. A landscape view may not have a point of interest that immediately draws the eye, so take time to consider what is to be the main focus and where and how to place it within the composition for maximum effect. Buildings, trees, the sun and clouds can all be employed. Remember also that the focal point doesn't have to be large or imposing, but that it should look natural within the landscape.

The 'Rule of Thirds' is a tried and tested method of dividing the picture area. Imagine overlaying a grid of thirds on your view and use it as guide to position the horizon and the focal point. Use natural devices, such as paths or rivers, to lead the eye toward the focal point. There is nothing wrong with altering or adding to the scene to make the focal point more arresting (see page 16).

In the drawings on this page, a house is the obvious focal point; in each case, however, the viewpoint, placing of the horizon line and methods of leading the eye in are different. Much of my work is done on location in flat landscapes, where a telegraph pole or clump of trees is the focal point, forcing me to look hard at the viewpoint, light and picture format, to get the most from the landscape.

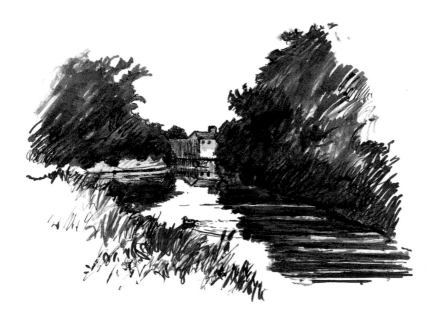

HOUSE ON RIVER IN PEN AND SEPIA INK
The view chosen for this drawing makes it very easy for the house to be the focal point – the foreground bank leads the eye on to the river, which in turn is 'directed' by the overhanging trees, and particularly their shadows. Everything converges on the distant house. Note, too, that leaving the sky area blank allows the top edges of the trees to provide a counterpoint to the highlighted areas of the river, and again leads the eye to the focal point.

HILL AND HOUSE IN GRAPHITE STICK AND PENCIL
Although it might not seem likely at first glance, the viewpoint in this drawing is quite similar to the one above: both houses are focal points and seen from eye level, and the greater part of each drawing leads to the house. Here, the wire leading from the left of the picture area across the house helps to draw the viewer's eye. The house is also placed on an intersection of thirds.

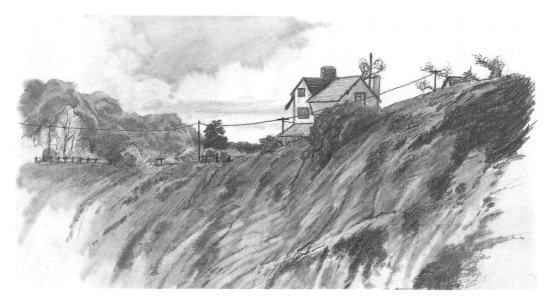

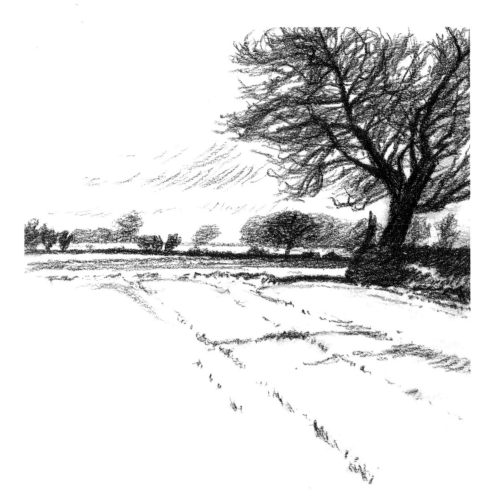

FIELD AND TREE IN PASTEL PENCILS
Choosing a low viewpoint means that the dark, menacing shape of the tree on the right is the focal point. Although the furrows on the field are leading away from the tree, just a few cast shadow marks across them lead the eye back towards it; the sketchy lines for clouds also mass from left to right, working as direction finders.

EVENING SKY IN PENCIL
The horizon line is very low in this drawing, and has been reduced to a dark mass broken by an upright tree shape and two verticals. The white cloud that bisects the vapour trails is directed straight to the focal point, the sun, which is framed by the horizontal lines of the darker clouds coming in from the left. The white upper edges of the lowest bank of clouds repeat the trails.

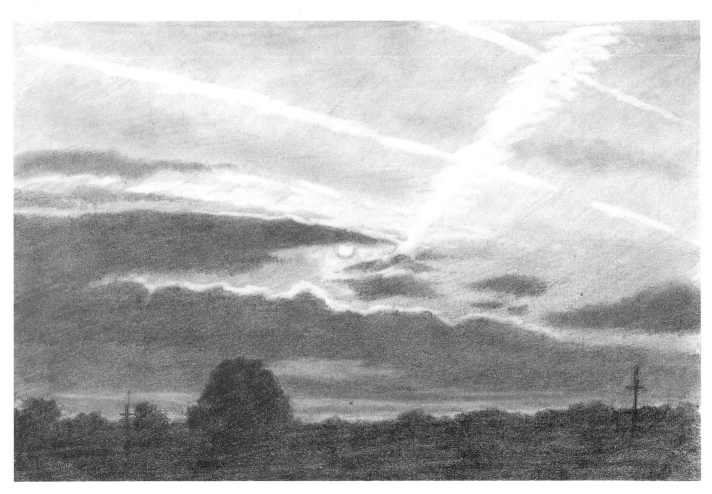

Choosing the picture shape

Traditionally, a landscape picture is wider than it is tall – hence the term 'landscape format' to describe this, the most popular shape. And while it is true that landscape format is very versatile, allowing you to place the focal point and horizon line where you will, there are advantages to be had from considering and experimenting with other formats. In addition, breaking the 'rules' can be very liberating and will encourage you to expand your repertoire of possibilities.

Square and upright portrait formats are often used for studies of vertical landscape subjects – trees and tall buildings, for example. However, it is worth investigating how these formats can be used to bring about unexpected and striking effects. Portrait and square framing can bring the viewer closer and more intimately into a scene. This could create a feeling of claustrophobia, anticipation or unease; on the other hand, such closeness is a good way to introduce detailed drawing and observation.

The attractions of using a panoramic format are obvious – it enables you to create a sense of the size and space of a landscape – but take care if you go down this route, because it is all too easy to end up with a view that has no real focal point and interest.

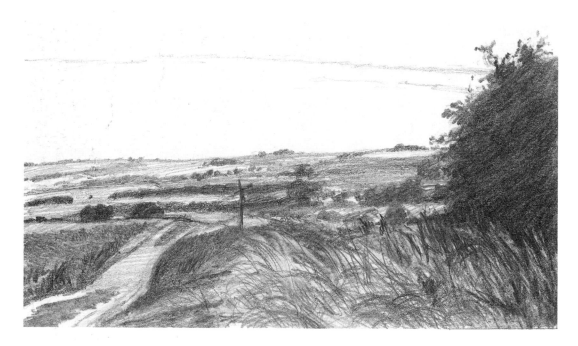

LANDSCAPE FORMAT
This is the classic landscape format, which allows artists to capture a view in the same way that they look at it naturally. Here, the horizon line is halfway up the drawing, but it can be easily moved, depending on the viewpoint, without much change to the effect.

TIPS

■ Even if you have already decided on the format for a particular drawing, it is worth taking a pair of L-shaped pieces of card and adjusting them to different formats (see page 36). You may be surprised at the changes in mood that can be achieved by a simple adjustment of one or both pieces.

■ Following on from this, it's also good practice, if you have the opportunity, to sketch the same view within different formats; the drawings need not be finished but should provide enough information for subsequent study or possible re-drawing and working up in the studio.

■ A more radical method of getting away from traditional picture formats is to make drawings on ripped or torn pieces of scrap paper. Fill the scraps right to the edges with part of the view in front of you, and leave out what doesn't fit on the paper – don't try to impose a rectangle or square.

SQUARE FORMAT

With less to see on either side, the scene becomes more condensed and the foreground is more immediate in its impact. As in the format opposite, the vertical post is kept off-centre, in a nod to the Rule of Thirds (see page 10) and as a way of providing interest.

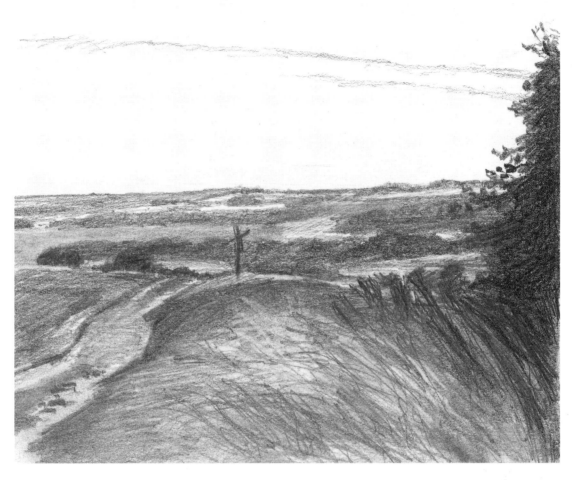

PANORAMIC FORMAT

With more of the left-hand side of the view visible, another vertical feature helps to ground the composition and hold interest. The track is now closer to the centre of the drawing, and the horizon line is higher.

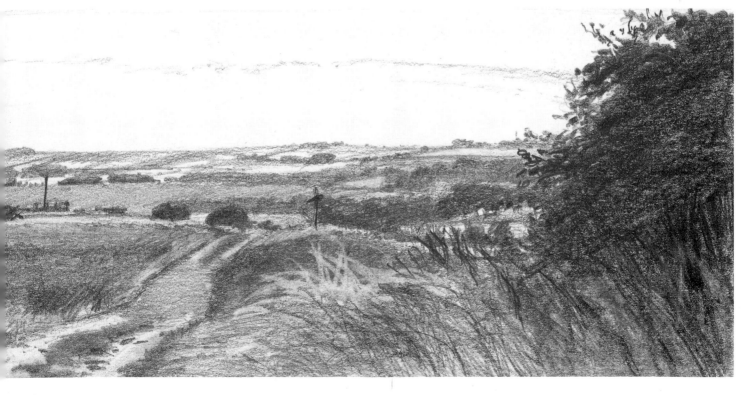

Choosing your viewpoint

Taking some time to find the best place from which to draw a landscape would seem to be an obvious part of the process, but it is surprising how many people rush in and start without looking at the alternatives.

Walking even a few paces to the right or left can make a substantial difference to the end result, and the same can be true of moving forwards or backwards. Work with a view-finder (see page 36) in each new position, and be prepared to crouch, or even lie, down while you check out each new possible viewpoint. And even when you are satisfied that you have the view that will work for you, stop and turn all the way around slowly, in case another possibility emerges. If nothing else, the gentle exercise will do some good!

Some traditional rules hold true – a high horizon line and low viewpoint tend to produce an enclosed or even cramped feeling, while the opposite gives an impression of space and airiness – and it is worth giving some thought to the emotions you wish to convey through them. On the other hand, don't feel hamstrung by having to make all your viewpoints conform to the Rule of Thirds (see page 10): the only useful fact about a viewpoint is that if it is unobtrusive and contributes to the success of a picture, it works.

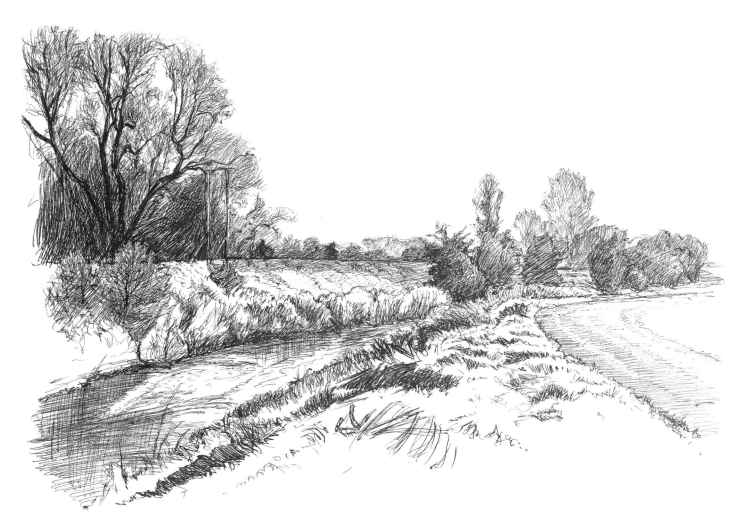

BROAD VIEWPOINT IN BALLPOINT PEN The first of this series of sketches shows how including as much as possible in a scene is both advantageous and disadvantageous. From this viewpoint the curve of the river and the edge of the field almost converge at the focal point of the trees on the right; however, the vertical lines of the tree and posts on the left tend to diffuse the effect, and the softening of the focal point through accurate drawing of aerial recession (see page 56) further blurs the impact.

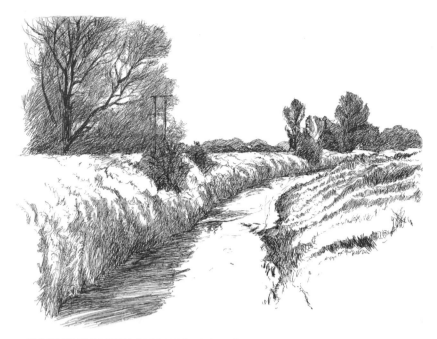

CLOSE TO THE RIVER IN BALLPOINT PEN Shifting position to the river bank itself instantly makes the brightness of the water and its curve the most important part of the composition. The river and riverbank lead the eye directly to the trees on the right, establishing them as the focal point.

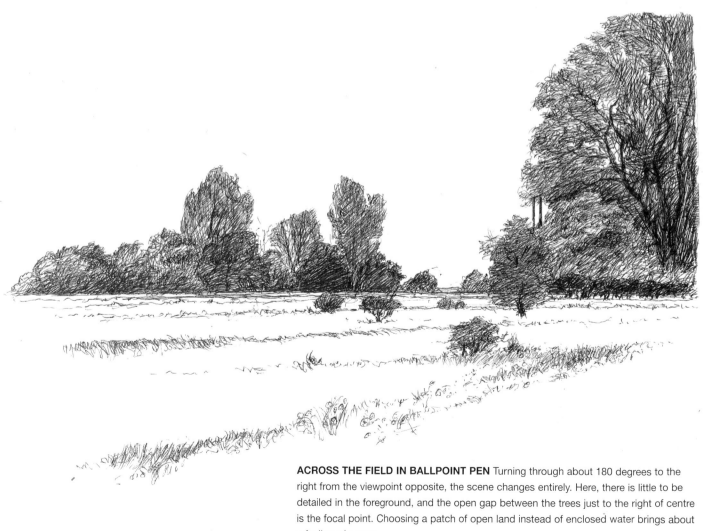

ACROSS THE FIELD IN BALLPOINT PEN Turning through about 180 degrees to the right from the viewpoint opposite, the scene changes entirely. Here, there is little to be detailed in the foreground, and the open gap between the trees just to the right of centre is the focal point. Choosing a patch of open land instead of enclosed water brings about a feeling of space.

Altering reality

As illustrated by the photographs and drawings on these pages, altering reality usually involves either taking unwanted or obtrusive objects out of the view before you, or adding things to balance a picture or to create interest in it. Whichever course you decide on, don't go ahead until you are sure that doing so will improve the drawing – make sketches and studies to try out your plans before embarking on the picture itself.

This said, omitting objects is relatively straightforward, but pitfalls can occur when you decide to add parts, and to avoid these it is almost always necessary to do extra work. Not only must the shape of the object be accurate and the angle at which it is placed conform to the viewpoint of the drawing, but if added shadows and highlights are not of a piece with the rest, they will stand out like a sore thumb.

The answer is not to be too ambitious or to introduce new elements that require more research than the subject needs. In the drawing opposite, for instance, a tractor or farm implement could have been inserted instead of the large bale and would have been in keeping with the theme. It took less time, however, and fitted the composition better, to make studies of one of the bales in the actual view and the shadows it cast on the field. Keep things simple and give yourself more time to get the whole drawing right.

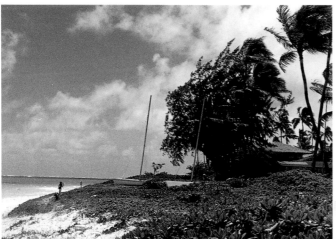

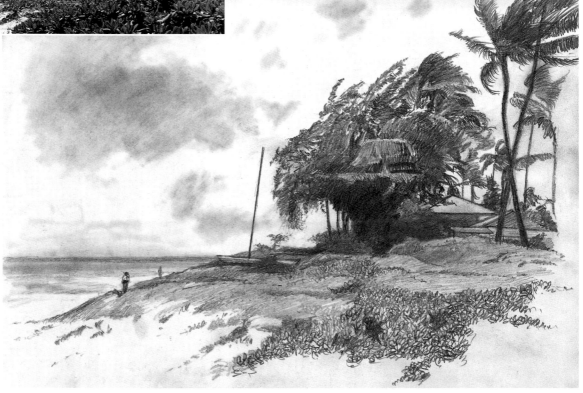

OMITTING ORIGINAL FEATURES – TROPICAL SHORE IN GRAPHITE STICK AND PENCIL The basic composition in the photograph was interesting, but the mast of the right-hand boat cut across the palms and made the scene look cluttered. By omitting it in the drawing, the impact of the remaining mast was increased, with its angle being mirrored as a single vertical more effectively by the tree trunk on the extreme right. In the same way, the figure in the boat on the left of the photo was not necessary to the composition and removing it provided the sea with the impression of greater space and openness.

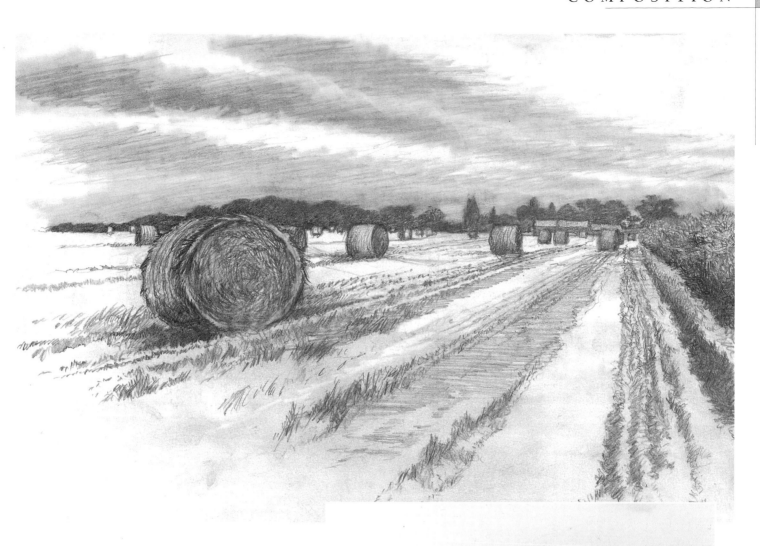

- *Modern computer programs such as Adobe Photoshop or Illustrator, and digital cameras are easy to use and can be handy shortcuts to deciding whether to omit or add to a picture, and if so, what. Use them sparingly, however, as an aid to your drawing, not as an end in themselves.*

- *As an exercise, try altering reality by reversing the colour tones and contrasts – block in normally warm tones as cool ones and vice versa. As an adjunct to this, use a variety of media to draw the same subject, and see how what you use can change the final result.*

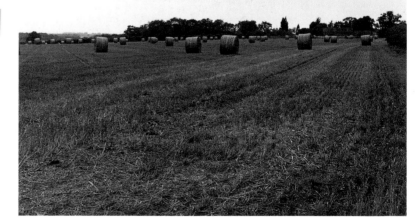

ADDING FEATURES – HAY FIELD IN GRAPHITE STICK AND PENCIL As seen immediately in the photograph, this scene was crying out for something in the foreground that could act as a secondary focal point. The first course of action was to omit the whole lower part of the photo, thus bringing the converging furrows to the edge of the drawing and leading the eye into the picture. The directions of these lines was reinforced by leaving alternate strips of land as blank, negative spaces. To balance the composition, one extra bale was added on the left, but this was carefully kept below the tops of the trees on the horizon – any larger, and it would have been in danger of overpowering the scene. Finally, the washed-out sky on the photo was changed, to reflect the lines on the field and to – paradoxically – give the whole drawing more space.

'There is nothing ugly; I never saw an ugly thing in my life: for let the form of an object be what it may, – light, shade and persepctive will make it beautiful.'

JOHN CONSTABLE (1776–1837)

Light and shade

Types of light

More than still-life or portrait artists (unless they work out of doors regularly), landscape artists are both at the mercy of, and guided by, the light that illuminates and infuses their subject – which also changes by the minute and therefore has to be chosen and captured in one frozen moment. The study and practice of drawing light is invaluable, and the time spent pays dividends.

Each adjective that is applied to light reveals a different facet – strong, weak, intense, diffused, shimmering, direct, reflected, luminous and so on – and you can use different techniques to achieve these effects, some of which are explored in the following pages.

Think about making both colour and monochrome studies of a scene to establish the type and effect of light – the different tones revealed in a pencil monochrome study can be eye-opening. Also, consider carefully the medium you use. The strong colours found in crayons or oil pastels, for example, are naturally better suited to making studies of bright, intense light, while the dusky subtlety of charcoal and graphite, and sheer range of colours of soft pastels, are ideal for portraying misty, diffuse light.

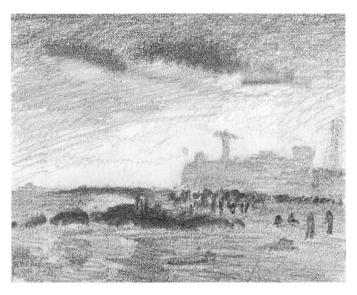

HAZY LIGHT IN GRAPHITE STICK Choosing the appropriate medium can go a long way to conveying light effects. Using thick, soft graphite sticks in this drawing meant that the emphasis had to be on the shapes and their relationship to each other in the diffuse light – with no attempt to draw details. The overall soft, muted quality is broken only in the centre and on the top sides of the clouds.

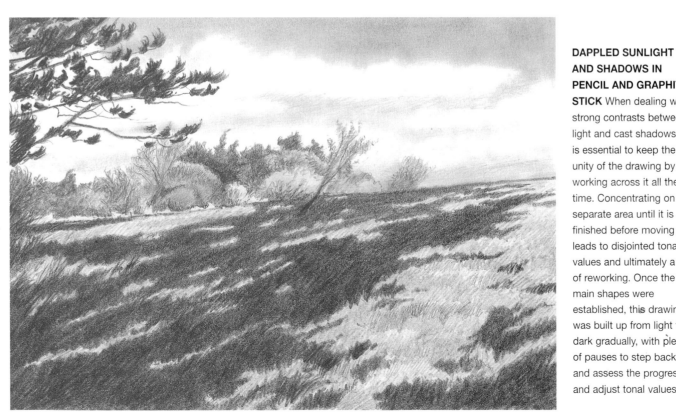

DAPPLED SUNLIGHT AND SHADOWS IN PENCIL AND GRAPHITE STICK When dealing with strong contrasts between light and cast shadows, it is essential to keep the unity of the drawing by working across it all the time. Concentrating on a separate area until it is finished before moving on, leads to disjointed tonal values and ultimately a lot of reworking. Once the main shapes were established, this drawing was built up from light to dark gradually, with plenty of pauses to step back and assess the progress and adjust tonal values.

Practice exercise:
Strong sunlight in pastels

Here, the challenge is to show a shadow that has a sharp line, without losing the unity between it and the areas in strong sunlight. Also, the main shadow across the wall has a different colour base from the more intense shading at the bottom of the foliage. Working in pastels means that any colour mixing must be done on the paper. Take care to avoid over-darkening the shadows, particularly next to the brightest parts. I used a toothed yellow paper to enhance the effect of afternoon light.

1 above Use a HB pencil lightly to establish the basic shapes in the composition, including the sharp shadow lines. Block in the area of direct sunlight with a white pastel. At this stage just suggest variations in the wall surface.

2 left Go over the sunlit wall with deep cadmium yellow, then use loose strokes of may green to add the grass and top foliage areas. Apply cadmium yellow over these areas for reflected sunlight, and repeat this over the darker grass and foliage, drawn using olive green. To build up the tonal values, apply lemon yellow over the sunlit wall, then establish the sky colour with bright cobalt blue.

4 below To finish the gate, block in the colour then apply orange earth, to lighten it, and burnt sienna, before drawing in the details with dark brown. Finish the sky and furthest foliage, then draw in the stone with Prussian blue warmed with violet. Look across the whole picture and add a little purple tint to the darkest foliage.

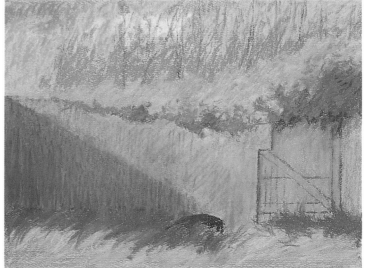

3 above Add some clouds with white pastel before turning back to the shadow on the wall. Use a torchon to blend light strokes of cadmium red tint 4, and repeat the blending with cadmium yellow tint 4, burnt sienna and reddish purple for a rich, dark shadow that contrasts with the yellow sunlit area above. **Inset:** Brighten the wall with strokes of lemon yellow. Add brown ochre for the tree trunks and gate. Go over the sunlit wall with spectrum orange and the grass with Hooker's green, this unifies the area without losing the strength of the shadow.

Practice exercise: **Sunlight through cloud in pastel pencils**

This is a study in creating light and shade effects through the use of pure colour, without the aid of shadows. The vitality and drama of this scene is dependent on the rendition of the sun's rays bursting through the cloud. I used pastel pencils and a torchon to blend them, working on sketchbook paper that was not too grainy, but which had enough tooth to hold the pastel dust. The texture of

the paper becomes an integral part of the drawing and adds to the diffused impression of light.

If anything, the skill here lies in successfully capturing the directions of the shafts of sunlight without allowing them to dominate the rest of the composition; I used the torchon as much as the pencils, blending the colours for a realistic and striking effect.

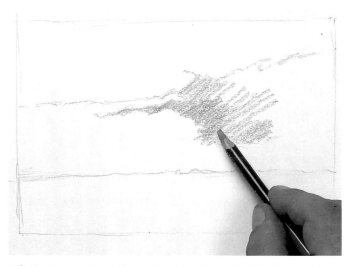

1 Start by roughly positioning the horizon line, using light strokes of French grey, then find the shapes and positions of the edges of the clouds with the same colour. Using the side of the pastel pencil, block in the darkest cloud areas with long, light directional strokes.

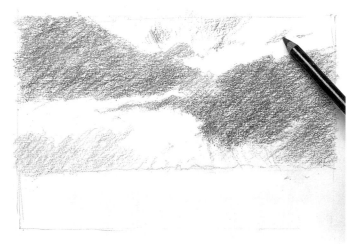

2 Continue to fill in the darkest cloud areas, using the negative spaces created by the lightest parts of the sky. Go over the grey gently with Prussian blue, then alternate between this and the grey to build up the colours and establish the tonal contrasts and the wisps of cloud. Even at this early stage, look for the movement of the sun's rays above and below.

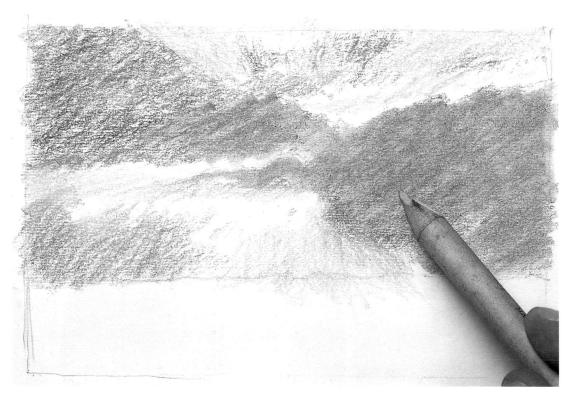

3 Use brown ochre to add the darkest sun colours and edges of the clouds, working over the grey and blue. Then apply a few directional strokes of light sienna to suggest the direction of the rays, all the time blending the colours in layers. Find the lightest colours of the clouds with light blue and grey, working with little pressure at first, then establish the land below. Now use a torchon to blend the cloud colours and prevent them from becoming too linear and grainy on the paper.

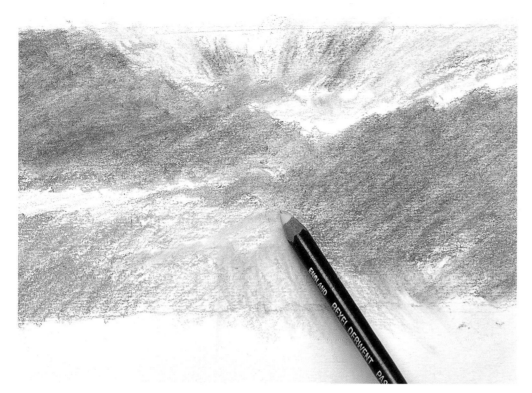

4 As you blend the clouds, leave the yellow edges, then start to draw the sky around the clouds, using strong directional marks to establish the rays. Move through the colours to strengthen and emphasize the rays – use orange earth sparingly, and deep cadmium yellow around the edges. When the colours have been worked in strongly, use the torchon to blend and diffuse them where required.

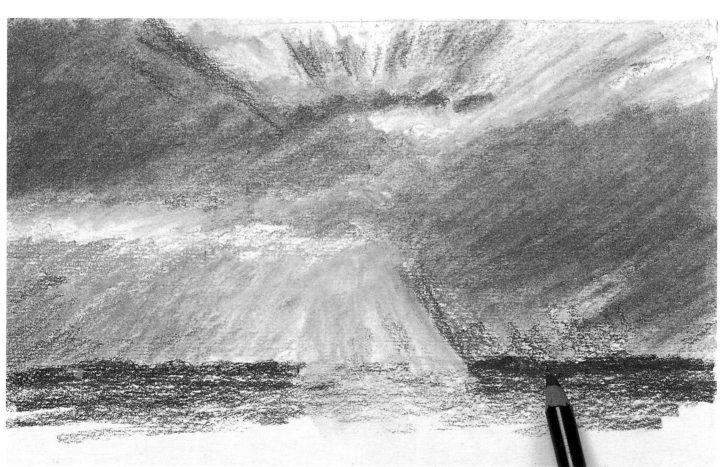

5 Continue to blend the colours over the whole picture using the torchon, then stand back to reassess before strengthening any areas further. Fill in the land with Prussian blue and crimson lake near the horizon – this is to show the effect of the rays. Work carefully so as not to go so far that the drawing becomes overworked and loses vitality.

Direction of light

After examining the kinds of light that you are likely to encounter in landscape drawing, the next consideration is to look hard at just where the light is coming from, and how best to capture it. The portrayal of the play of light on objects in a landscape, and the shadows it casts, is not always immediately noticeable when it is done well – but it is the first thing that jars if it is inaccurate.

When working on location, because you are in one place for a period of time, you can see how changes in direction and the height of the sun, and the season of the year, can affect the scene you are drawing, sometimes from minute to minute. So it is a good idea to decide early on what the mood of your work is to be, and to choose the light to match – for example, low evening summer sunlight creates a calm, warm effect, while winter sun in the morning may throw shadows in a similar way, but without the warmth.

Allied to the direction of light is the colour that emanates from the sun, which allows you to create striking and unusual effects. Sunrises and sunsets are particular favourites, as they can also involve showing the light direction on clouds as well as on the land. As always, draw what you see, not what you assume you see – light in nature has enough variations without the artist inventing new ones.

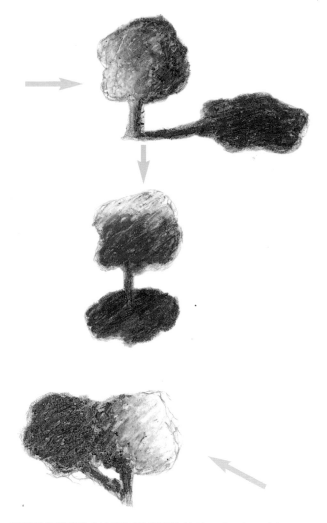

QUICK STUDIES IN WAX CRAYONS Making sketches of the same tree at different times of day in summer sunshine is useful practice for accurate drawing. The arrows indicate the direction of the light. Note how the colours of the shadows are different in each sketch, and how much of the mass of foliage and trunk is also shadowed – in the middle drawing, three-quarters of the subject is in dark shadow where the midday sun is directly overhead.

LENGTH OF SHADOW IN COLOURED PENCILS In winter (right), because of the low position of the sun in the sky the cast shadows are long and contain cool colours; the bare branches are also elongated. In summer (below), the same tree has grown leaves, and the higher sun casts a shorter, bulkier shadow that incorporates warmer colours.

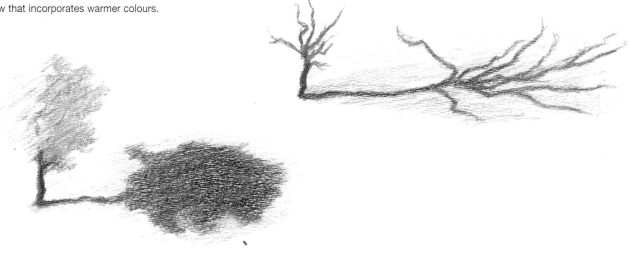

TIPS

■ *You can use a simple home or studio set-up to study the fall and direction of light. Start by placing objects on a table – they don't have to imitate those found in a landscape, but can be almost abstract if you prefer – and then light them from all angles and heights, using overhead and movable light sources, while sketching and studying the results.*

■ *Photographs are fine for showing the direction of light, but if you are working primarily from a photo, you must be aware that the colours on the landscape that indicate the direction of light are very unlikely to be accurate. Even brief notes and scribbles of colour made at a scene can be invaluable for convincing renditions.*

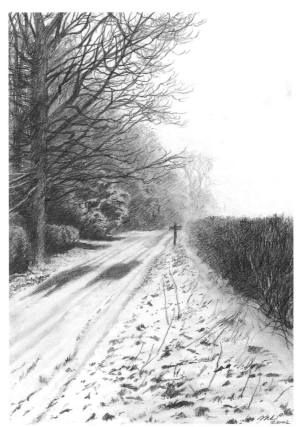

MISTY WINTER DAY IN SOFT PENCILS In this scene, it was almost impossible to tell from which direction the light was coming, as the mist and grey winter clouds produced an almost opaque light quality. The dark patches on the road are not shadows but areas of melted snow. To emphasize the soft, muted quality of the scene, soft pencils (HB, 2B and 5B for the darkest tree tones) were used, with a torchon to blend the greys. Leaving the sky blank adds to the diffused mood.

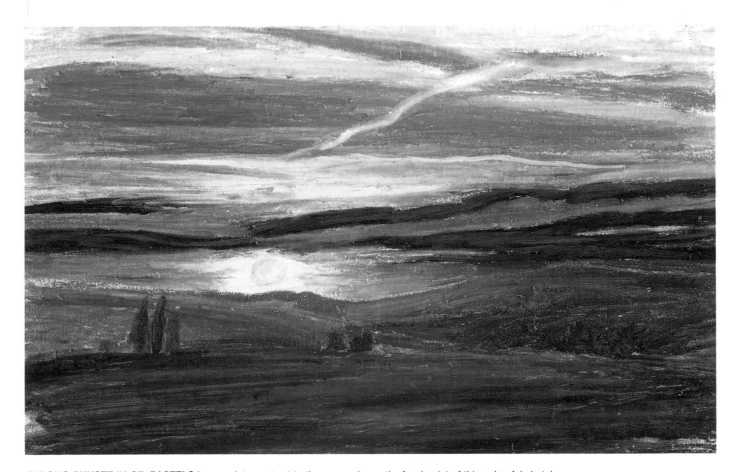

STRONG SUNSET IN OIL PASTELS In complete contrast to the scene above, the focal point of this colourful sketch is the setting sun. Bright oil pastels are very useful for recording the incredible range of colours, from pale yellows and blues to suffused purples, oranges and reds, all of which are reflected in muted tones in the land below. When the sun is this low in the sky, everything beneath it is in shadow.

Shadows

For such insubstantial and two-dimensional objects, shadows offer the artist a large and challenging number of options in a landscape. The first consideration is to observe their shape, tone and colour; the second is how to portray them effectively.

Shadows are not pure black; this may appear to be an obvious statement, but it is surprising how many people use shortcuts to draw or paint them. There are gradations of tone and depth of intensity even using a monochrome medium, as shown in the ink drawing on page 28. (The exception here is working solely in black ink at full strength – in this case, the drawing effectively takes on an illustrative quality that is not necessarily concerned with accurate colour representation.)

Simplifying the fall of shadows can produce powerful shapes, but these are more accurate when the tonal variations are included. To capture these subtleties, you should be prepared to use whatever drawing tool comes to hand – a finger or torchon to spread and blend soft media like charcoal or graphite, or a paper tissue or a finger to move ink around and dilute it.

Continued on page 28

TIP

■ *A useful exercise in depicting shadows is to loosely sketch the same scene two or three times, each time changing the colour temperature, from high summer to midwinter, for example. Then stand back and take a dispassionate look at the drawings: do the shadows all capture the mood in the same way? Are there any areas that stand out as being right or wrong? You can also try to exaggerate the colours – in the style of Matisse or Cézanne, perhaps – and look at how doing this affects the end result.*

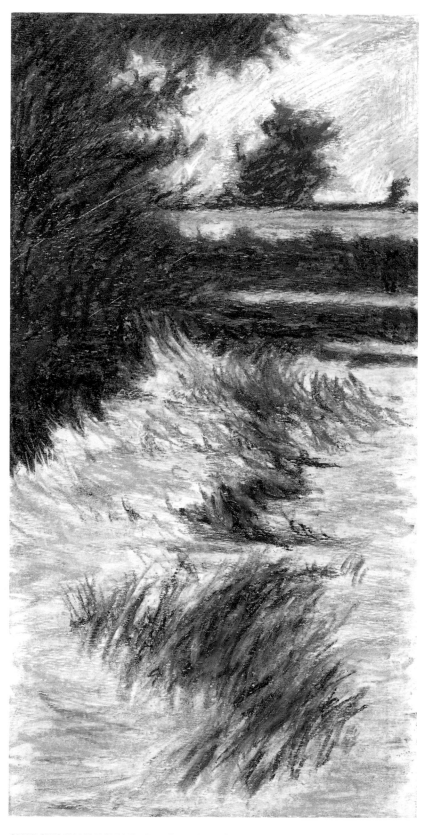

SHADOWS IN HOT SUN IN WAX CRAYONS This sketch was made using wax crayons, whose bright colours mean that any subtlety of tones must be created through building up layers. Even on the brightest day, cast shadows are never black, but hold some of the overriding warm and hot colours of the landscape around them. Here, the purple and brown of the trees were carried into the shadows, which used similar short, stubby strokes to create the impression of the land beneath. In the same way, the lightest 'yellow' of the ground was made up of browns, reds and greens, together with warm and cool shades of yellow.

Practice exercise: Shadows on snow in watercolour pencils

This study in reflected shadows on a snowy landscape was made with watercolour pencils on smooth, white drawing paper – but there is no white left in the finished drawing. I used the white paper to help find the negative shapes, but felt that it was too stark for the effect of late-afternoon light. Taken in isolation, the snow foreground could be seen as a deep blue sea with white horses of foam on its crests – if you see this sort of resemblance, go with it!

1 above Working tentatively, make compositional marks to fix all the various parts of the scene, including the trees and shadow lines. Using the side of a sharpened ultramarine watercolour pencil, lightly block in the first colours of the shadows on the snow.

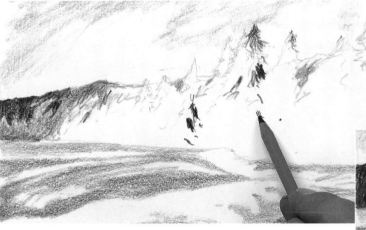

2 above Check both the positive shapes of the shadows and negative ones of the snow while adding the foreground shadows and shaping the land contours. To find the first tonal values, add imperial purple to the mountainside, cobalt blue for the sky and cedar green for the trees.

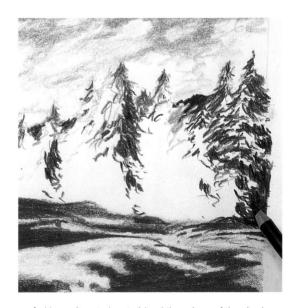

3 left Continue to blend layers of green and purple for the tree shapes, then strengthen the main shadow areas with layers of ultramarine and purple. Use more pressure, working the pencils into the smooth surface of the paper.

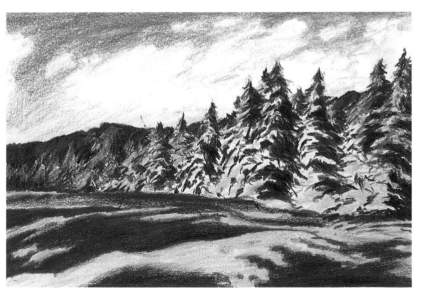

4 Use softer strokes to blend the edges of the shadows into the snow. Look at the whole picture and strengthen the layers of colour throughout. Slightly darken the sky at the top, then use flesh pink to soften and warm up the white on the snow highlights and in the sky.

5 Add more cedar green to the trees and a light layer of purple to warm up the darkest shadows. Gently add more flesh pink to the white areas, blending it with ultramarine to show the contours of the snow and the foliage.

Going straight to the darkest tone, even for shadows in bright light, offers you no chance of revising and amending the area as the picture takes on its tonal values – and makes it impossible to work over the shadow again if a rethink is required.

When it comes to drawing with colour, look for the tones and hues that are present in every shadow, and use them to reinforce the colours and tones in the rest of the picture – warm colours on the land produce warm shadows, and the same effect is true of cool-toned drawings. Once you have established this in your mind – and made studies that demonstrate it – you will find it invaluable in producing drawings that have a sense of unity.

Look also for the differences between the various types of shadow in the scene you are drawing. Cast shadows on the ground invariably take on different colours from those shadows that are actually on the object, and the area where the two types merge or meet one another may be a third colour entirely. Shadows can often be used to anchor the base of an object onto the ground and set it firmly in its place in a scene.

Cloud shadows also fall into two categories: those in the cloud itself, and shadows cast onto the ground by clouds. The first category is determined by the strength of the sunlight and the season, and can be quite spectacular – think of the shadows cast by colourful sunsets – with purples, oranges and deep reds all available for use in the shadow areas.

In the second category, where the cloud casting the shadow is not necessarily seen by the viewer, it is important to depict the shadow accurately: it must not obscure the contours of the ground, while the edges of the shadow area are unlikely to be strongly defined, but be more wispy or breaking up as it falls over trees and fields.

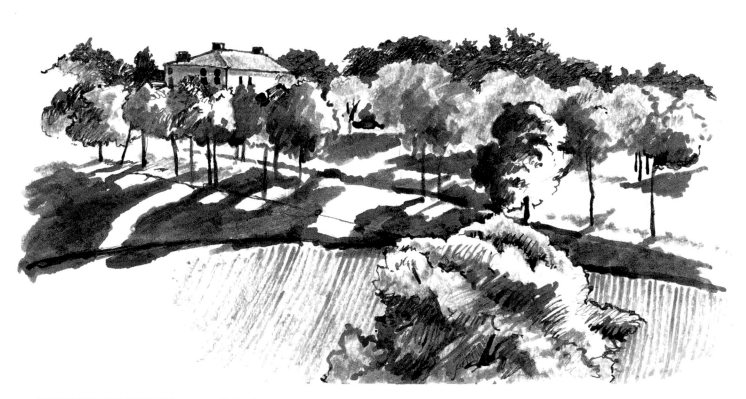

SHADOWS IN INK WASH This scene, with low light casting the shadows from the rows of trees, might seem a difficult one to draw in pen and ink. However, this drawing was made using a small torchon dipped in varying dilutions of brown ink, starting lightly and building up layers of darker tones. A pen was used only at the final stages, to draw in small details and lines to pull the picture together. This soft-edged way of creating light and shade demands as much confidence and bravura as using a pen – you can't erase and re-draw – but the results can be very effective.

Practice exercise:
Summer shadows in watercolour pencils

In an open landscape of rolling hills, the effect of a cloud passing between the summer sun and the ground can be strong and dramatic – almost as if the clouds have been pasted onto the land. This exercise gives you the opportunity to consider the cloud shadow mass as a major and integral part of the composition. I used a relatively small number of watercolour pencils to layer the colours and tones, with a torchon for final blending and softening. With a view of this kind, I was also able to concentrate on the contrast between the strong colours in the foreground and the diffused ones on the hills further away (see Aerial recession, page 56).

1 Lightly sketch in the basic shapes of the hills, trees and cloud shadows using the side of an olive green pencil. The contours of the hills and foreground should also include the main shadow masses as an integral part of the whole composition.

2 Strengthen the olive green once the shapes are in place, and add the ribbon-like edge on the hill. Use may green to block in the hills, working with more pressure on the nearer ones. To establish the tonal range, block in the far mountain with a warm, pinky yellow-orange, overlaid with a graphite stick.

3 Extend the darker colours to cover the shadows, switching to a brighter leaf green to balance them and provide contrast. Start the foreground cornfield with an orange-yellow, then extend this onto the far mountains and even over the leaf green. Use a dark cedar green to show the contours of the land and the right-hand tree masses.

4 To tone down the more garish colours on the hills, go over them with very light strokes of olive green. Use the same colour to fill in the trees and contours of the hills. Warm up the shadow mass with scarlet lake, then add directional strokes of scarlet and yellow ochre on the cornfield. Shade in the sky with a light cobalt blue, working the pencil in hard – then blend this blue with a torchon for a smoother overall effect.

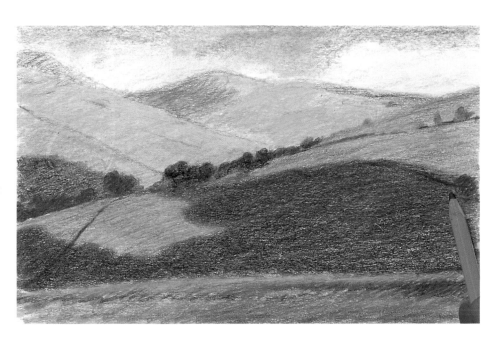

'Objects must be portrayed in their particular context, and they must be especially bathed in light, as is the case in nature.'

ALFRED SISLEY (1839–1899)

Working outdoors

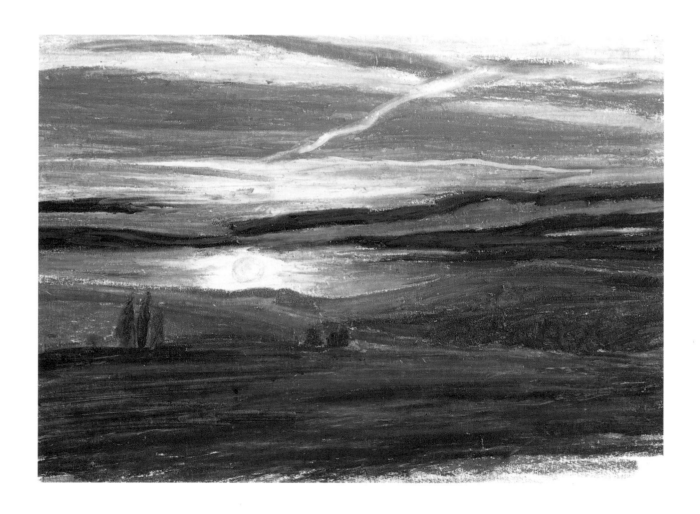

Using reference material

Sometimes it seems that nothing in the past has aroused more controversy than the use of reference materials for landscape drawings and paintings – but these days the sheer proliferation of inexpensive cameras, both film and digital, and creative computer programs means that most pressing concerns are not **what** you use, but **how** to use it.

The one vital piece of reference equipment is a sketchbook in which you can draw, write and make colour and detail studies; anything else should be a back-up to this. It is worth taking more drawing tools than you need, just in case a particular scene or effect can best be achieved with one or more media. The most important thing is to come back with material that you can work from.

As always, buying the best you can afford is a good rule of thumb, and there are a number of reliable, inexpensive small cameras that can be slipped into a pocket and carried everywhere. Some artists even include a lightweight tripod and compact video camera as part of their standard location equipment. Whatever the gear you use, make sure that you use it only as a back-up to your own direct observation and interpretation of a scene: photographs and video film can do no more than provide a two-dimensional representation of a three-dimensional scene.

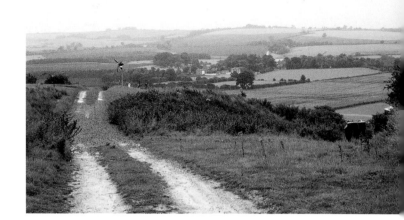

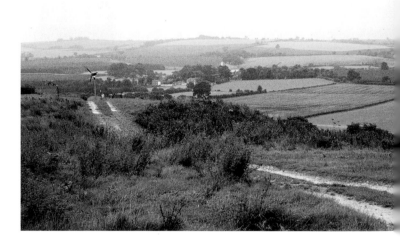

PHOTOGRAPHS AS REFERENCES Where possible, try to take more than one shot of any potential scene – the lower photograph (right) shows more of the distant fields on the right and more detail of the scrub and grasses in the foreground than the alternative above.

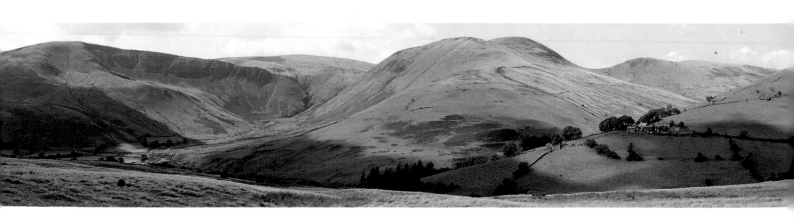

HOME-MADE PANORAMA You don't have to cart around vast amounts of camera lenses or extra equipment in order to collect wide views of a scene. This panorama was made by trimming and taping together three separate prints, which were taken from the same spot, moving the camera around a few degrees each time.

DIGITAL CAMERA IMAGES Taking views on a digital camera and then transferring them onto a computer and adjusting the tone and colour range, can be a useful aid to deciding which parts of the scene you may want to emphasize. Even the size at which you view or print out a shot can make quite a difference.

TIPS

■ *Be prepared to revisit a scene more than once if you do not get down enough reference on the first visit. Don't assume; observe.*

■ *In addition to photographing the overall view of a scene, take close-ups of any details that you may need later; making notes of the shots you have taken is another way of ensuring that you can use reference material quickly and efficiently.*

SKETCHBOOK NOTES Artist's sketchbooks are their most creative source of ideas, so use them to the full. Colour notes and swatches, verbal and visual descriptions, everything is grist to the mill – even for subsequent drawings that have nothing to do with the original reference scene.

Speed drawing

The ability to make quick, telling sketches and drawings is an invaluable tool for the artist and can be practised at any time and in any location.

The first thing to consider is for what purpose do you want to make speed drawings: as a guide for more studied work back in a studio; as a record of a changing or ephemeral scene; as a way of improving your technical skills; or, most likely, as a combination of these and other factors, not the least of which is the pleasure that can be derived from the ability to set down a scene quickly for its own sake and nothing more.

The second consideration is what medium to choose. Most artists tend to use pencils because they are portable and do not create a mess, but almost everything that can make a mark should be a possibility: ballpoint, marker pens and felt tips are very useful, and if you are willing to take ink

SKETCHBOOK STUDY IN PENCIL A small sketchbook can be slipped into a pocket or bag and used at any time. Make sure you use one with hard covers, to protect the edges of the pages.

to locations, you can use anything from a fine pen nib to a twig or stick to make marks. Even watercolour can be used: many manufacturers produce small travelling sets that are easily portable. Working outside your usual boundaries like this can be a great way of finding new methods to express what you see in a landscape.

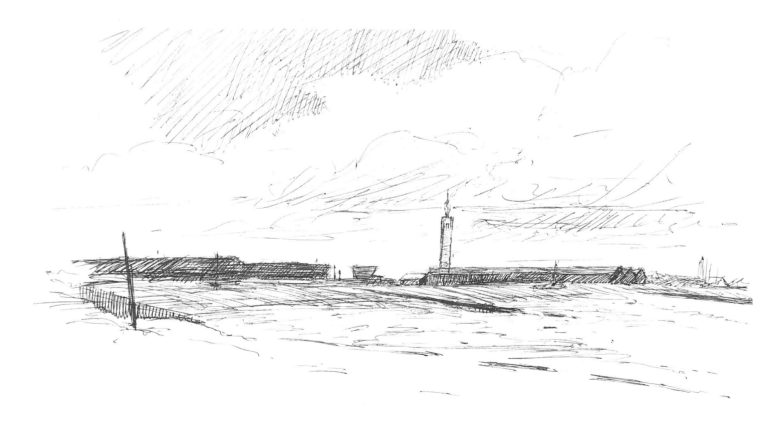

15-MINUTE SKETCH IN BALLPOINT PEN Even in such a linear drawing, the sheer variety of ballpoint marks needed to portray the land and sky can be surprising. This sort of indelible medium requires confidence and decisiveness from the artist (although 'searching' marks often add vitality to a quick sketch), so it is worth building up a repertoire of marks in as many situations as you can.

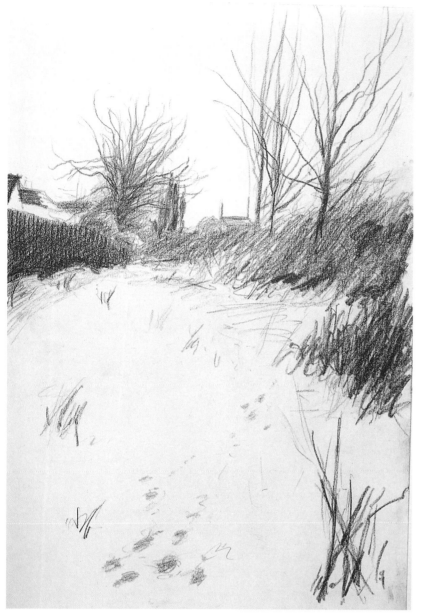

20-MINUTE SKETCH IN WATERCOLOUR PENCILS

Having a good selection of pencil colours to hand made it easy to work quickly. In addition to the shapes and forms, the most important feature here is the recession, from foreground to background, in the view. With colour, the best method is to start by lightly applying the basic tones before firming them up and adding any details; the reflected colours in this kind of snow scene require as much careful observation as those spotted at first glance.

20-MINUTE SKETCH IN PEN AND INK

Pen and ink is a remarkably good way to set down basic shapes quickly, as the spontaneity of indelible lines and marks has an immediate, exciting quality that is difficult to achieve with erasable and amendable media. Here, the stark quality of the silhouetted shapes is emphasized by leaving the sky area completely blank, letting the paper do the work and thus making every stroke of the pen a telling one. The greatest danger with a sketch of this kind is overworking it, so discipline yourself to stop drawing once the sketch has been developed from the basics, and take a hard look to see whether anything else is needed, rather than attempting to fill all the open spaces.

Field equipment

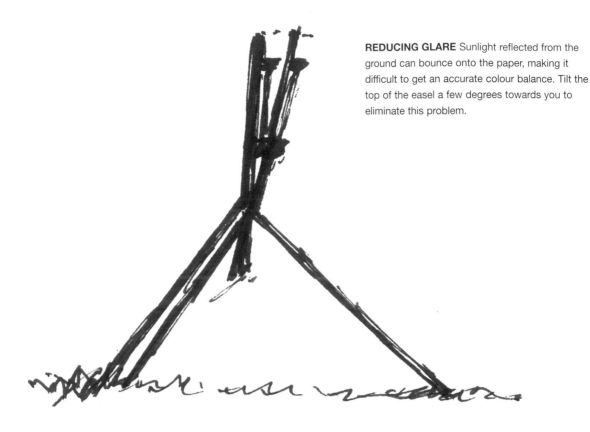

REDUCING GLARE Sunlight reflected from the ground can bounce onto the paper, making it difficult to get an accurate colour balance. Tilt the top of the easel a few degrees towards you to eliminate this problem.

Look at the advertisements in any art-instruction magazine, and you will see a bewildering number of pieces of equipment for drawing and painting on location, each claiming it is the best. The selection and tips here are not intended to be definitive, but to show what I use after many years of work and selection.

One essential is a large rucksack, preferably with a waist strap, to reduce the pressure on your shoulders and back, and a number of outside pockets so you can keep smaller items away from larger ones. Buy the best you can afford, and ensure that the stitching and straps are strong and well

RUCKSACK Look for sturdiness in construction and stitching (avoid fancy and flimsy ones). A waist strap is pretty well essential and exterior pockets are a good idea.

made; military-surplus shops are good sources. Easels that have drawing boxes incorporated are fine if you have a car and can drive very near to your location – if not, they are inconvenient and unwieldy to carry for anything other than short distances.

When it comes to what to carry inside the rucksack, my view its that it is better to bring too much than too little – most drawing mediums weigh nothing in themselves, and you will soon learn from experience which ones you are unlikely to use and can leave at home.

Pay some attention to what you wear. A well-fitting hat is essential, both for warmth in cold weather and to keep the sun off your head and neck in summer or hot climates. Of course you don't want to wear too much in such hot, sunny situations, but if you do wear T-shirts or short-sleeved tops, and shorts, a strong sunblocking cream is vital. The perennial problem of cold feet can partly be solved by wearing one or more pairs of thick socks inside boots – and cut out and carry a couple of pieces of white expanded polystyrene (used to pack electrical appliances): to stay warm, stand on these, or put them under your feet when you sit down to work.

FOLDING SEAT There are some very strong, lightweight models on the market – mail-order catalogues have many – but try one out before parting with your money.

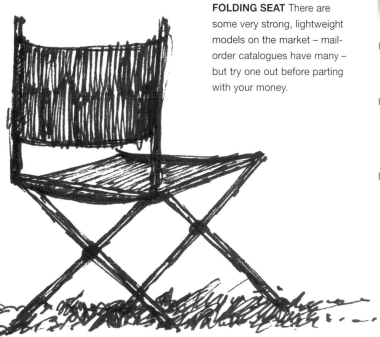

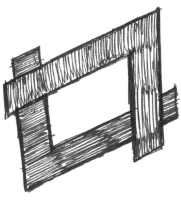

VIEWFINDER Two right-angled strips of card are easily constructed, and you can keep them flat inside the covers of a sketchbook. Use them to frame a composition and to decide on its format.

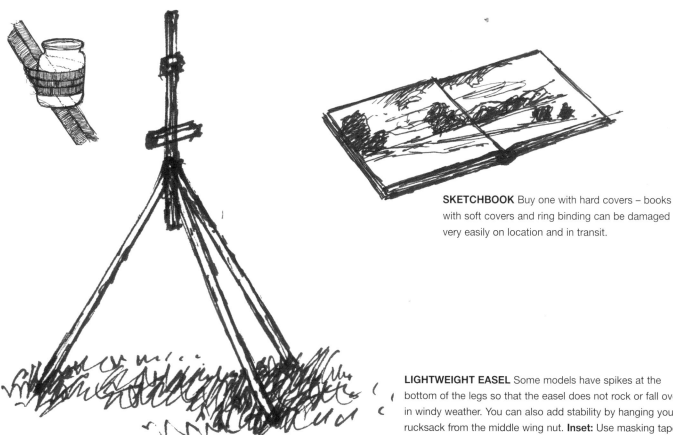

SKETCHBOOK Buy one with hard covers – books with soft covers and ring binding can be damaged very easily on location and in transit.

LIGHTWEIGHT EASEL Some models have spikes at the bottom of the legs so that the easel does not rock or fall over in windy weather. You can also add stability by hanging your rucksack from the middle wing nut. **Inset:** Use masking tape to fix jars and containers to the legs of an easel. They provide handy storage for pens and pencils.

'…the sky is the keynote, the standard of scale, and the chief organ of sentiment…the sky is the source of light in nature, which governs everything.'

JOHN CONSTABLE (1776–1837)

Skies

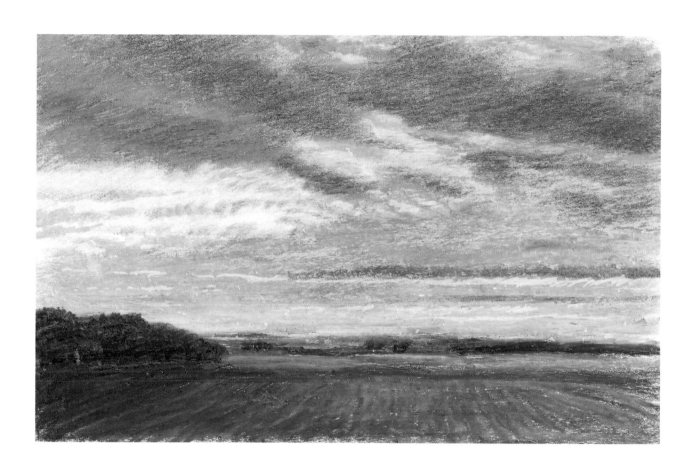

Clouds

Clouds can change the mood of a landscape in a moment – from calm to menacing, and from light to dark; and their shapes are never more than transient, being pulled and moved about by prevailing winds and their own weight.

The way you delineate clouds can be affected greatly by the medium you use; the same clouds can be shown as darkish shapes against a clear or underworked landscape in a dusty, loose medium like graphite powder, or they can be outlined in pen and ink as pale, negative shapes against a darker and more detailed landscape. A useful project would be to draw the same cloud-scape from a reference photograph in different media, noting how each one brings alternative qualities to the scene.

There is also something to be said about altering reality in the way that you use clouds in a composition.

Continued on page 42

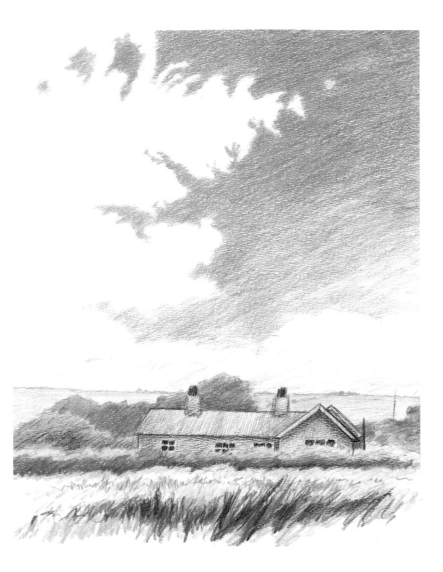

CLOUDS IN WATERCOLOUR PENCILS
Although the cloud shapes were drawn as negative shapes, they are not left pure white – the yellow in them reflects the light in the sky that is also repeated on the land and roof.

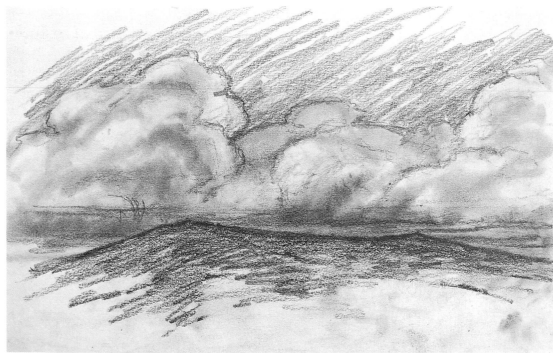

CLOUDS IN GRAPHITE STICK, PENCIL AND GRAPHITE POWDER
Here, the three-dimensional nature of the billowing clouds was achieved by drawing soft, rounded marks with a torchon and graphite powder. This produces a larger, less substantial effect than the tighter, harder lines of the land and the long, directional strokes in the sky.

Practice exercise: **Billowing clouds in pen and ink**

The wind blew these cumulus clouds into great rounded, billowing shapes, and their movement contrasted with the solid mass of the hills below. At the same time, the cloud undersides had similar tonal values to the sky above, throwing the hills into stark relief. I used a steel nib and sepia ink to show the shapes, and soaked a small torchon in ink to draw the wash tones. You cannot erase or go back too often using pen and ink, so be prepared to work quickly and confidently – if things go irreparably wrong, you can always start again.

1 Establish the outline of the horizon, making tentative marks to find the basic lines of the hill, and rough loose strokes to suggest their bulk and form. Draw the cloud shapes lightly but confidently – don't be afraid of going over what you have done to find the right line, as these searching marks can add to the dynamism of the medium.

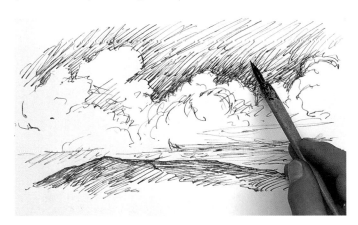

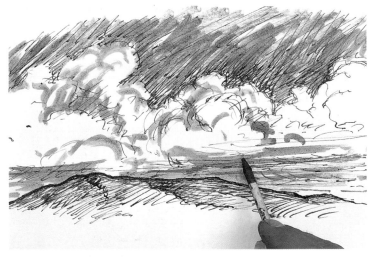

2 above As you continue to make the shapes of the clouds, add a little loose hatching to bring them forwards, and longer horizontal lines for the bottom edges. In the clear sky above, use looser hatching marks the further away from the clouds you get.

3 right Dip a torchon in the ink, allow it to soak in a little, and use it to tone the hatching. Draw the billows with large, free strokes – don't try to overelaborate, but look for the sense of movement in them.

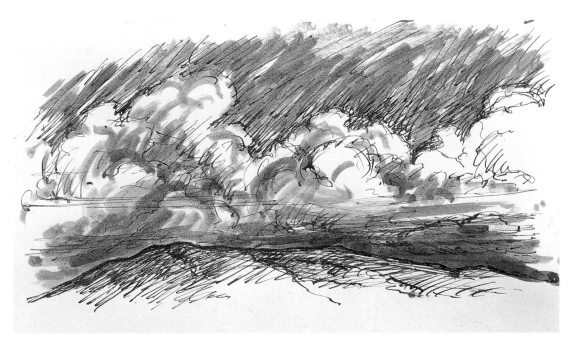

4 Work over the torchon washes with the pen to give even more movement to the billows, and make extra lines to define the base of the clouds. To reinforce the washes and add paler ones, dilute the ink and apply with the torchon, working over the whole drawing. Stop before the picture looks overworked.

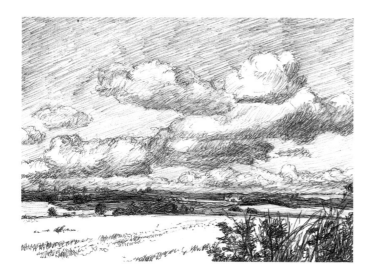

In the drawing on page 17, the addition of a few directional cloud streaks helps to lead the eye towards a focal point in the distance. However, be careful that you don't overdo such effects – there is enough interest in most clouds to keep you occupied in setting them down in the first place.

Think of clouds as three-dimensional forms, with a top, side and base, defined by highlights and shadows. If anything, high, wispy, insubstantial cirrus (mackerel) and flat, low stratus clouds are the most difficult to capture successfully, compared to billowing cumulus clouds. The art here is to treat them as an integral part of the sky area, not as something that is added once the rest of the sky has been set down. The clouds will almost certainly have reflections of the sunlight, sky and land beneath, giving them a unity with the rest of the landscape. A single cloud can be evocative of a still, windless day.

Even when you draw the sky around clouds and use them as negative shapes, pay attention to the highlights – it is rare for the whole cloud to be a bright white, and usually some colouring or shading will help to present the character of each individual cloud, even on an overcast day.

CLOUDS IN BALLPOINT PEN On a summer day, fluffy clouds can seem very close to the land. Here, the clouds were built up with a myriad of tiny strokes and layers. The short, scribbled marks are in contrast to the uniform hatching of the sky and the harder marks on the land. The blank paper of the field suggests strong sunlight.

CLOUDS IN PENCIL AND GRAPHITE PENCIL

This scene in Hawaii is an exercise in tonal drawing – the aerial recession between the two sets of hills is completely over-shadowed by the dark undersides of the clouds. In their turn, the clouds are mirrored by the clear sky on the right, almost like a land mass on a map.

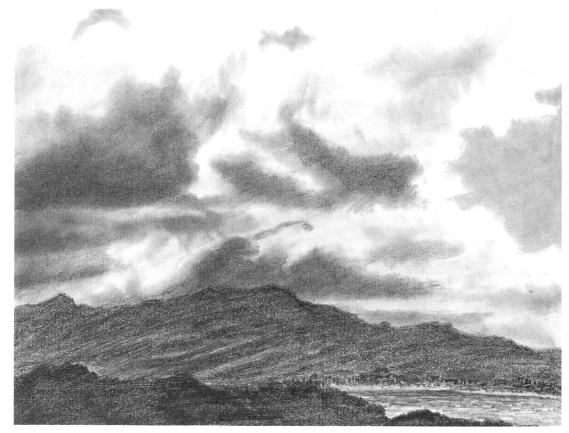

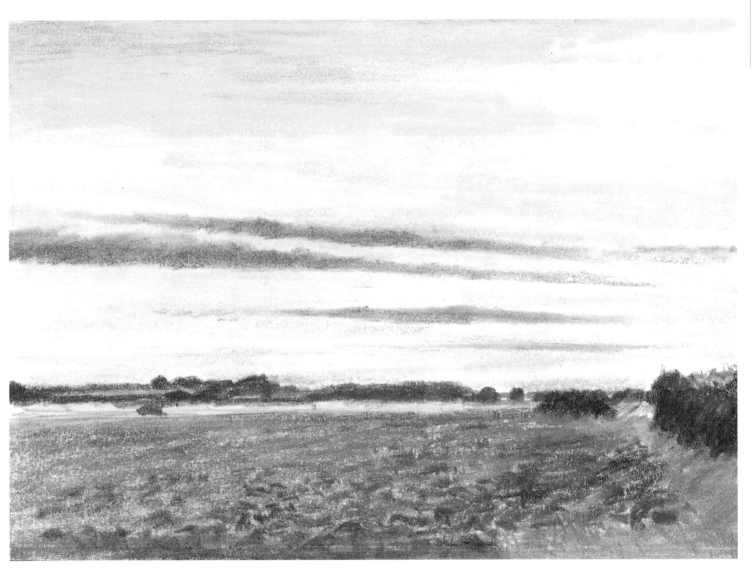

CLOUDS IN PASTEL PENCILS In complete contrast to the clouds opposite, these wispy, long grey clouds appear to have no movement, but to be lying above the equally elongated and flat landscape. The cool blue of the clouds is mirrored and intensified in the horizon line.

Clear skies

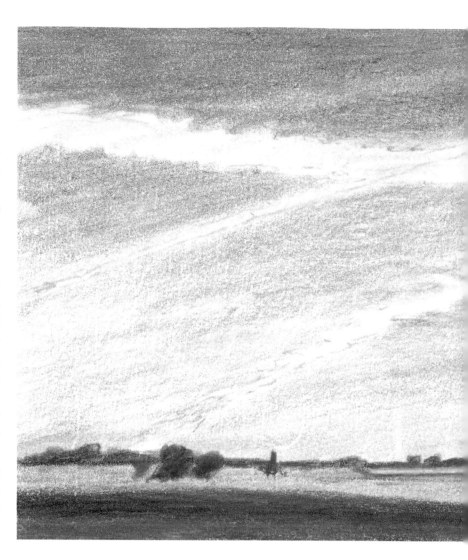

On a clear, still day, or one where there are few disturbances in the sky, the smallest cloud or vapour trail becomes a focal point. Even in Mediterranean or African skies at midday, the deep blue of the sky is not completely uniform, and it is the irregularities that can bring interest to a picture.

The physical qualities of drawing media mean that is is all but impossible to achieve a smooth, flat sky surface over a large area, and your aim should be to exploit this, especially when working in media that work best when layered – watercolour pencil and wax crayon, to name but two.

When the clouds in the sky are far away or faint you can experiment and practice by working on the tonal variations across the sky rather than drawing the differents cloud shapes within it. Work too lightly and nothing can be seen of the clouds; work too hard and they take on too obtrusive a part.

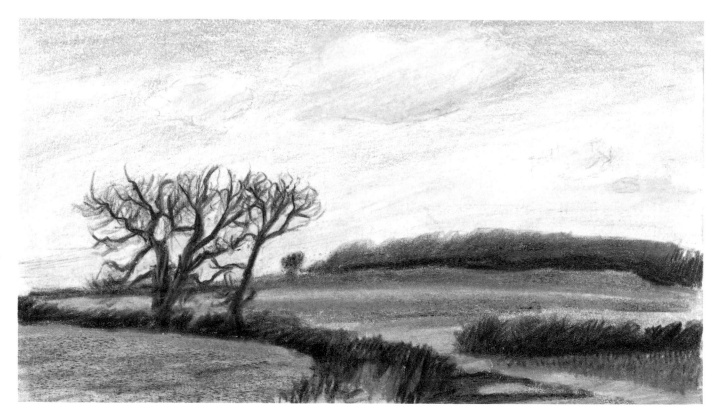

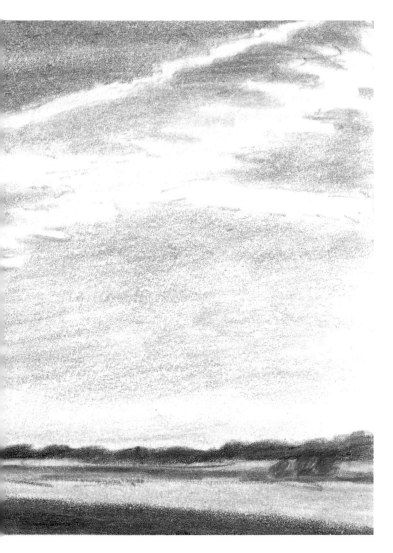

- *A large expanse of perfectly clear sky can be unsettling and appear unreal – look for any variations that seem natural.*
- *On a cloudless or near-cloudless day, the shadows on the ground will be strong and clearly defined, so make sure they are shown.*
- *One way to bring unity to a picture where the still sky and busier land are at odds with each other, is to build up the tones on a toned ground.*

VAPOUR TRAILS IN WATERCOLOUR PENCILS
The flat landscape is the best backdrop to the straight patterned lines made by the vapour trails. Note how the coloured areas of sky between the lines become negative shapes to the positive highlights of the trails – this kind of juxtaposition keeps you on your toes.

SMALL CLOUDS IN WATERCOLOUR PENCILS
(Opposite) The sky colour tells us that it is a sunny day, but only the top edges of the clouds are pure white, and their incorporeal quality is shown by the minimal amount of reflected colour on their undersides.

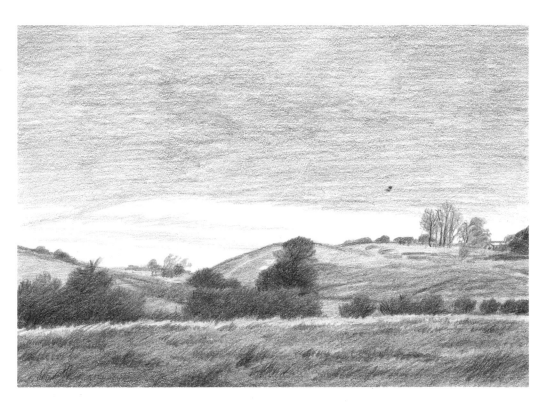

CLEAR SKY IN PENCIL Working in a monochrome medium, you do not have to make colour decisions and can concentrate on getting the right tone to reflect the light on the land below. If the sky were a little darker, the scene would take on the feeling of approaching night.

Colours of skies

The phrase 'sky colours' usually brings to mind the deep blues of a summer's day, but don't forget that even the bluest or greyest sky is far from being a uniform shade, and that variations in atmospheric pressure, width of cloud layer, and reflections from the ground all play their part in making different areas of sky colour.

The more intense the sky colour, the more this will be mirrored in the landscape, and the opposite is true: a grey, overcast day produces more muted colours on the ground. You can use this latter effect to advantage by having a bright colour as a focal point, even in the far distance.

The drawings on this page achieve very different effects through remarkably similar means – both seek a unity of tone, if not of colour, and both are convincing because they utilize layers and blends of warm and cool colours. Mixing your media is a good way to produce results.

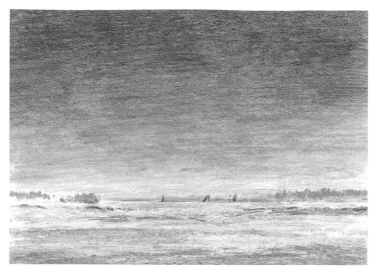

BRIGHT DAY IN WATERCOLOUR PENCILS, CRAYONS AND OIL PASTELS The change from the deep, intense blue-violet at the top of the drawing to the peach colours near the horizon was gradually built up. The brightness of the sky is echoed in the bright colours on the land.

OVERCAST DAY IN WATERCOLOUR PENCILS, CRAYONS AND OIL PASTELS A grey sky need not be cold. Layers of browns, greys, blues and even white were applied for the sky colour, and highlights were created by scraping the layers off with the edge of a sharp blade.

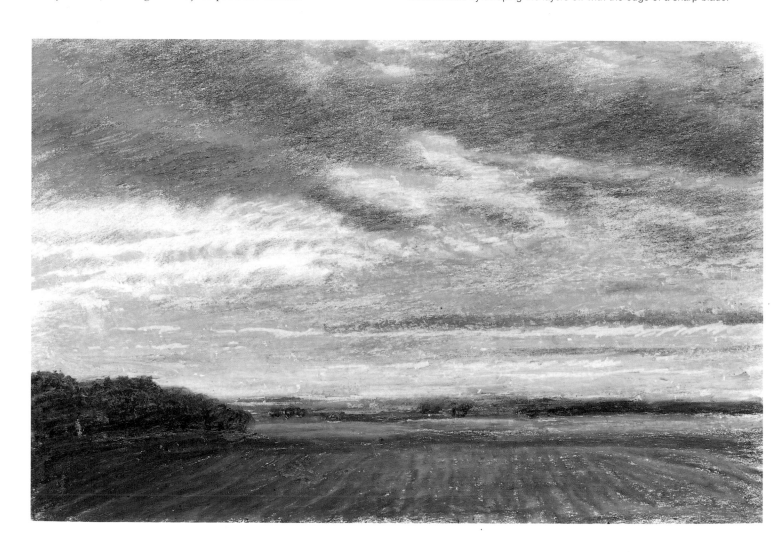

Practice exercise:
Early evening sky in pastel pencils

Used on their sides, pastel pencils have all the advantages of pastel sticks, with the bonus of being able to make relatively small marks with the tip, which can also be sharpened. The cool Prussian blue and violet of the sky and sea could be seen as being opposed to the warm cadmium and ochre colours of the setting sun's glow, but I worked on off-white sketchbook paper, which gave an underlying warmth to the whole drawing. Build up the layers of colour gradually.

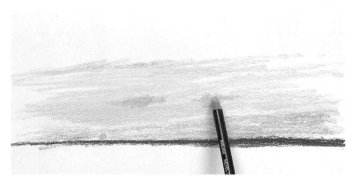

1 Set the horizon line with black and burnt carmine. Lightly set the low sky with pale spectrum blue and layer French grey on top. Draw the sun with zinc yellow and the glow with orange earth and deep cadmium; add the clouds with white and zinc yellow, with dark violet for the base.

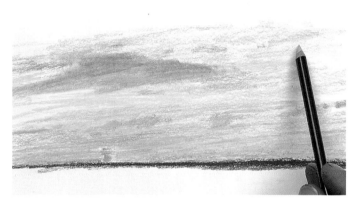

2 Work over the blue-grey with the violet, drawing strongly for the darkest cloud areas. Add spectrum orange to the bottom of the yellow, then deepen the rest with zinc yellow. Soften Prussian blue on the upper cloud with a torchon, then soften the layer above the horizon. Warm up the lower clouds with crimson lake, then use spectrum blue on the sky.

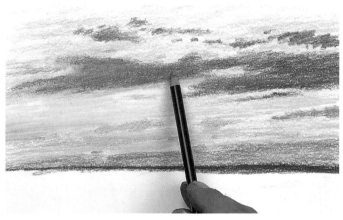

3 Finish covering the sky area, then deepen it and blend with burnt carmine before using carmine on its own for the small wispy clouds. Add dark orange earth across the lower sky, then apply a lighter version above this. Go over the carmine with Prussian blue, then use this over the darker areas. Knock the colours back with white if necessary.

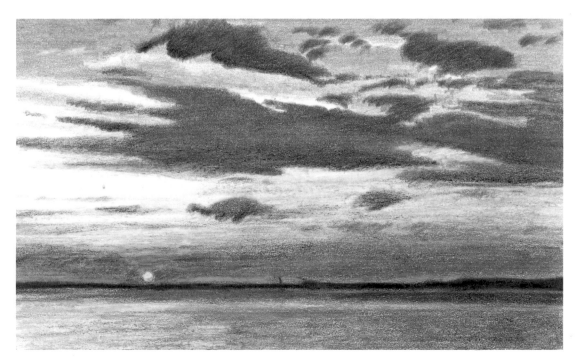

4 Concentrate on darkening the clouds and sea with Prussian blue. Use deep cadmium yellow for depth on the areas of sunlit glow, then reinforce this with brown ochre and add the ochre to the bases of the clouds. Work lightly between these darkest colours, but stop drawing before the picture looks overworked.

Stormy, moody skies

For all their 'sound and fury', it can be easier to draw stormy, moody skies than calm ones, where the differences between clouds and the sky beyond are harder to detect (see page 42). The contrasts between dark shades on rain-filled clouds and the sunlit highlights that can often be seen on their upper edges are a challenge to artists – portray the darkest areas in quick, soft media such as graphite sticks or charcoal, lifting off marks to add highlights.

In most stormy skies, the clouds are pushed by the wind or pile up in layers, often with relatively clearly defined edges and bottoms. Smudge a soft medium for movement, and define the edges with a hard medium.

Look out for the variations and amounts of colour in even the greyest-looking skies; in the practice exercise opposite, much of the drama and tension is created by adding just a little reflected light to the clouds.

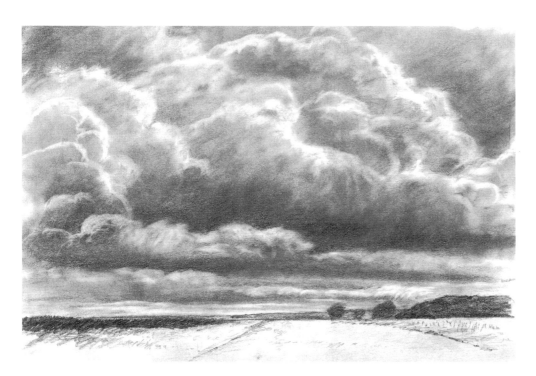

THREE-QUARTERS SKY IN PENCIL AND GRAPHITE STICK This drawing is dominated by the lowering, overcast sky, which completely overwhelms the land below it and makes it look very fragile indeed. The contrast between the highlighted edges of the clouds and the dark lower edges makes for a dramatic composition.

GLIMPSE OF SKY IN PENCIL AND GRAPHITE STICK The effect of moodiness and turbulence here is created not by focusing on the sky and clouds, but by isolating them between the dark masses of trees. Their shapes and angles, and the cast shadows in the foreground, reinforce the mood.

TIP

■ *The relationship between the sky and the land is crucial in drawing effective stormy skies. If the clouds are high or covering most of the sky, they may cast almost no direct shadows on the ground; isolated patches of moody, dark clouds create well-defined shadows. Practise drawing the same moody sky over affected and unaffected landscapes, and note the differences in both authenticity and atmosphere.*

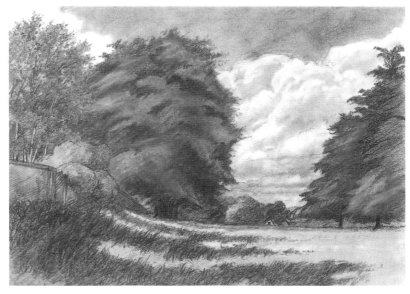

Practice exercise: **Stormy clouds in mixed media**

This is a detail of a very dark, stormy sky that appeared out of nowhere and changed the landscape from friendly to threatening in a matter of seconds. I used a clean, dry sponge and graphite powder, various sizes of torchon, a narrow 9B graphite stick, a kneaded eraser and burnt umber and dark grey pastel pencils, on lightly tinted paper. Graphite powder is wonderful for capturing the gradations of tone in stormy skies: simply smudge it with the sponge or your fingers to create great swirling clouds.

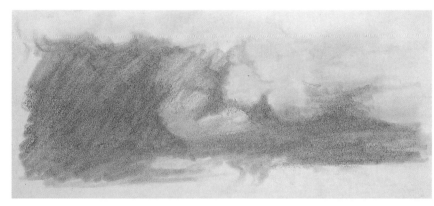

1 above Dip the sponge in the graphite powder and use it to make the basic cloud shapes. Blow off the excess dust and then push what remains into the paper with a torchon, adding powder as needed. Lightly suggest the billows using a graphite stick.

2 left Use the side of the graphite stick to reinforce the darkest areas on the left, working from dark to light and smudging the graphite with a finger. Switch to the tip of the stick for the lighter areas on the right and move the dust with a torchon.

3 Work across the whole picture with the torchon, softening the edges and using the torchon to draw in the trailing lower edges of the clouds. **Inset:** Cut a wedge from a kneaded eraser, and mould it to the required shape, then use it to lift out the highlights in the clouds and shape the layers.

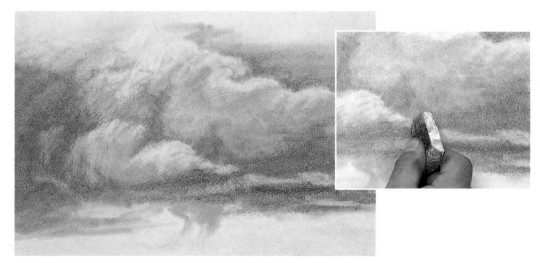

4 Continue picking out the highlights and lighter areas, looking for the directions of the wind and the weight of the clouds. Add a little reflected colour from the ground using a burnt umber pastel pencil and then a dark grey one, again softening the marks with a torchon. Return to the graphite stick to increase the tonal range.

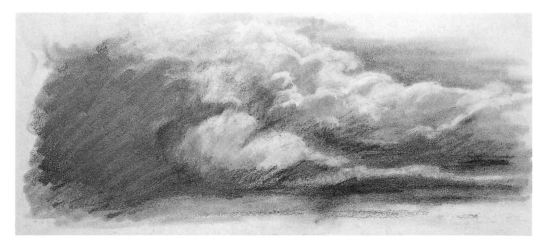

Cloud shadows

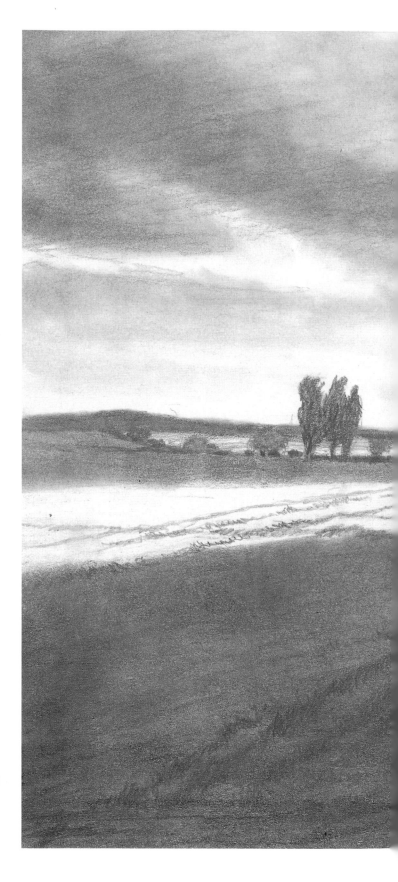

The preceding pages have examined dramatic effects such as rich, strong sky colours and clear and stormy skies, but one of the most striking scenes in a landscape comes when bright sunlight casts dark cloud shadows over fields and hills. There is something very impressive about shadows that have nothing to root them to the ground, and the contrast between the lightness of the sky and the darkness under the shadow is intense.

To achieve lifelike results when drawing these scenes, there are a few rules that should be remembered. First, always ensure that you include the shadow area as part of the whole scene – when you map out the composition, the shadow should be drawn at this stage, not added later. This is particularly the case when the shadow area takes up a large part of the picture, as in the drawing on the right.

Next, pay attention to the colours of the shadows – because they are being cast from a long way above the ground, they will not be as intense and dark as shadows cast from trees or buildings, for instance. It is inevitable that some of the colour of the land or objects on it will be there, plus any reflected colours – adjoining fields of oil-seed rape in flower and cabbages will have very different base colours. For this reason, build up layers of colours rather than going in with a dark colour to start with.

A large area of dark shadow makes the areas under bright sunlight much more intense, so you need to keep an eye on the relative colour temperatures; on a summer day, the overall effect will be warm, including the shadows, but a cold, sunny winter day needs cool colours.

Finally, make sure that you portray the contours of the land accurately in cloud shadows. This is often best done by layering and subtle gradations of tone and colour.

TIP

■ *Because of the speed at which cloud shadows can pass across a landscape, you may need to take quite a few photographs to help you decide which view to work on. And if you know beforehand that the conditions are right for cloud shadows, consider setting up a video camera (film or digital) so you can have the entire sequence of movement for subsequent study, and can freeze frames to have exactly the positioning you want.*

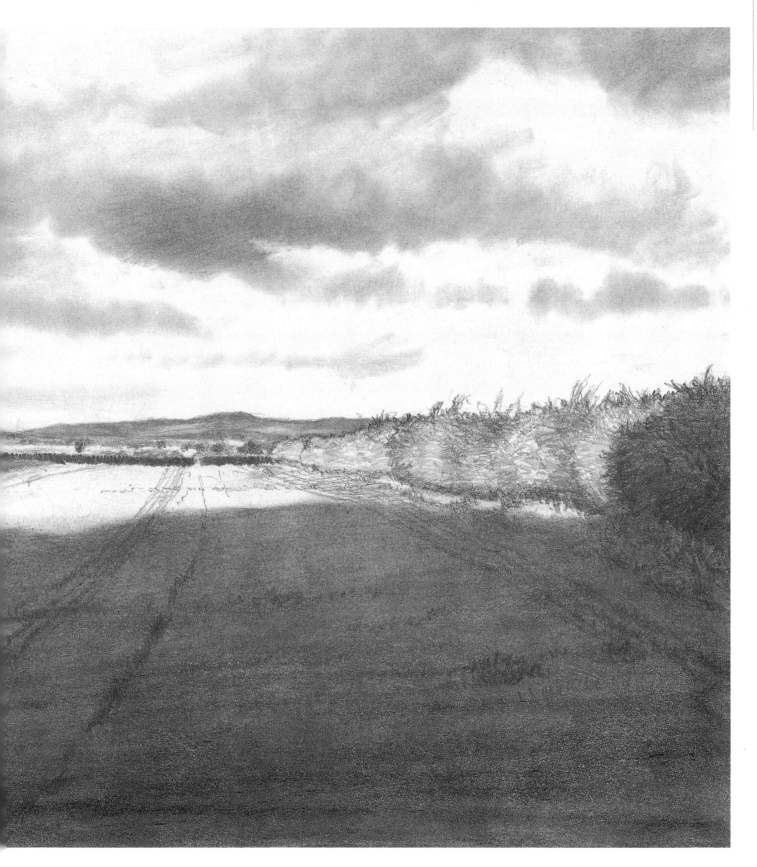

SHADOWS ACROSS FIELD IN PENCILS The shadows were racing across this sunlit field, so the choice of just where to arrest their movement was made to achieve a dramatic effect. The drawing was made with B and F grade pencils and a 6B graphite pencil, while a large and a small torchon were used to blend the shadow mass and the cloud shapes.

'*What a delightful thing this perspective is!*'

Paolo Uccello (1397–1475)

Mountains and hills

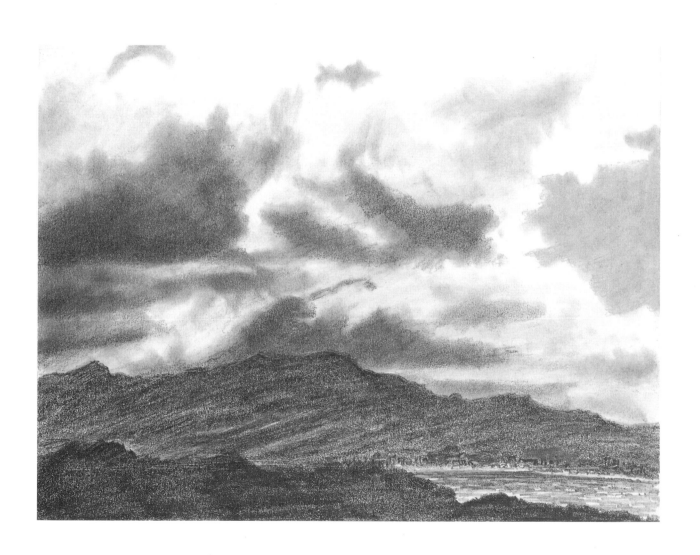

Shapes and textures

When setting up a composition that incorporates hills or mountains, the viewpoint is vital – the difference of only a few metres can change the shape of a hill completely – so take the time to check all the alternatives before making a decision. In addition, once you have found a pleasing or interesting shape, look hard at where it should be in the composition – in the picture below, having the peak in the centre of the drawing would regularize the composition and lose some of the drama of the scene.

When it comes to mountain ranges such as the Alps, Rockies or Himalayas, for example, you may have to do a little judicious altering of reality (see pages 16–17); too many peaks and snow-capped summits can be visually confusing, so concentrate on the shapes that matter most.

How much or how little texture you include can often be governed by the medium you use – pastels and oil pastels, charcoal and graphite powder tend to suit soft layers in large scale pictures where tonal variation is key, while pen and ink or pencil lends itself to detailed hatching and cross-hatching, to suggest the rugged texture of rocks or the sparse vegetation on a distant hillside, for example. You can also get in close and make studies of rock formations.

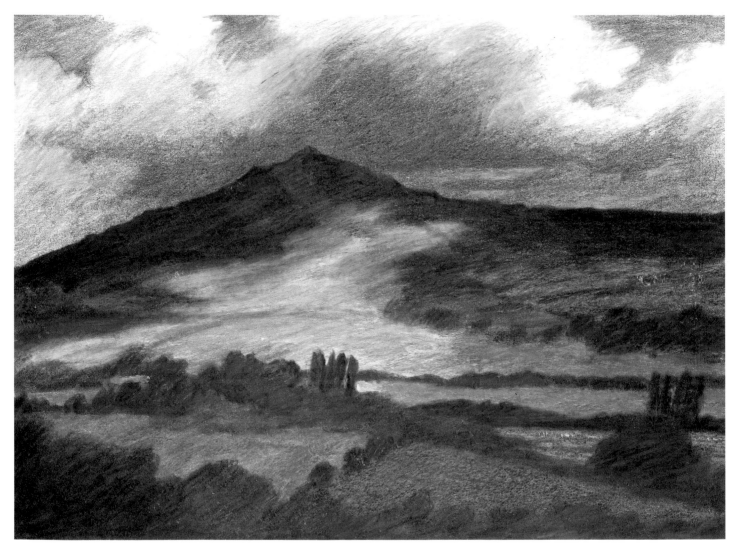

HILL IN WATERCOLOUR PENCILS The viewpoint chosen for this drawing is important – the clump of trees in the centre left middle ground and the sunlit fields above it lead the eye automatically to the summit of the hill. The ridge to the left of the peak is suggested by additional layers of colour.

Practice exercise: **Craggy hills in pencil and graphite**

One of the most effective ways of creating textures is through the use of contrast – this study is about drawing the positive shapes and textures of the hills against and around the negative shapes of the trees in the foreground, which makes you concentrate on the texture. I worked on a sheet of smooth drawing paper with a 2B pencil and HB graphite stick, plus a torchon dipped in graphite powder. I cut wedges from a soft kneaded eraser to pick out highlights and create light shapes against the grey graphite.

1 Use a 2B pencil very lightly to mark the outlines of the basic top shapes, including the trees in front of the hills. Work down the composition, sketching in the shapes of the conifers on the hills, but do not attempt to add details or tonal values at this stage.

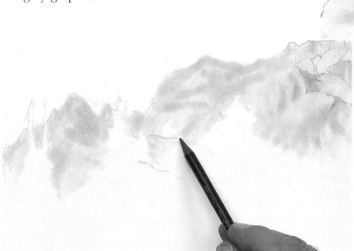

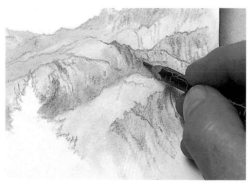

2 left Dip the torchon in the graphite powder and lightly block in an even shading of light grey over the whole hill area. Use a HB graphite stick to draw in the crags and fissures, then soften these with the torchon. **Inset:** Draw in the textural details on the rocks with the graphite stick. Build up the darkest parts gradually, and darken the edges of the trees, both for definition and as a contrast.

3 right To expand the tonal range, use the 2B pencil to add the darkest areas on the rocks, then switch back and forth with the torchon to fix the details and compare the various tones. Now you can concentrate on creating distance in the ridges and rock faces – creating form around and beyond the trees to make them stand out even more.

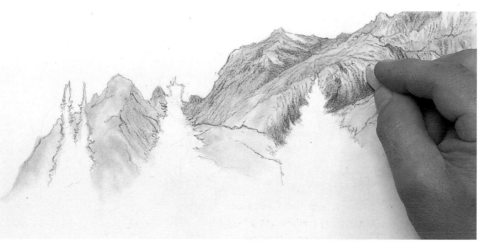

4 Continue to put in the darkest tones with the pencil, using a variety of short marks to describe the texture of the rocks and following the contours of the hills. Layer the darker patches and note where the light falls on the textures. To create highlights, cut a wedge of soft kneaded eraser and use this to pick out the white of the paper.

Aerial recession

The effects of aerial recession can be seen most clearly in ranges of hills that go into the far distance, with each farther hill appearing weaker and cooler in tone and colour as they recede. If you are making a drawing of distant hills, the emphasis will be on the larger picture, and the challenge is to convey a sense of space and distance. Contrast warm colours in the foreground with cooler ones in the far distance, and use lighter tones to suggest the haze of the horizon. Other devices are the use of diminishing size as objects, such as clouds, recede, or contrasts of texture between a detailed foreground and a softer background.

For this exercise I used various dilutions of sepia acrylic artists' ink on white sketchbook paper. Drawing with a finger is a wonderfully direct and straightforward way of making marks. It also forces you to concentrate on using tones and broad strokes to show shapes and textures as well as the differences in colour temperature.

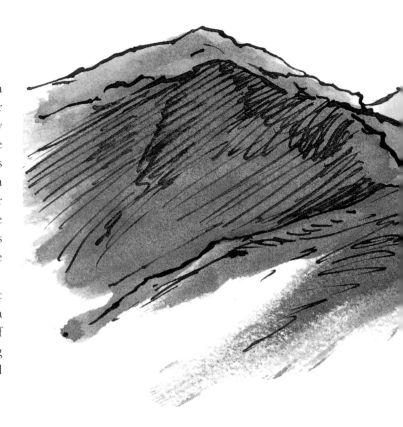

1 **left** In a segmented ceramic dish, make up dilutions of sepia ink, from full strength to 1:3 parts water. Very lightly sketch in the shapes of the hills with a 2B pencil, then dip a finger in the strongest ink dilution (not full strength) and apply it to the foreground area, rubbing along to block in the darkest tones. Follow the rough contours of the hill with finger strokes to show the direction of the land.

TIPS

- *Always make up more quantities of dilutions of ink than you think you will need for a drawing; it is frustrating and time-consuming to have to match a certain strength.*
- *Keep a piece of scrap paper by the side of the drawing, and test out each dilution before committing yourself to putting it down.*
- *In addition, write down the proportions of each dilution and label it as you go along. This aids making similar dilutions for future projects.*

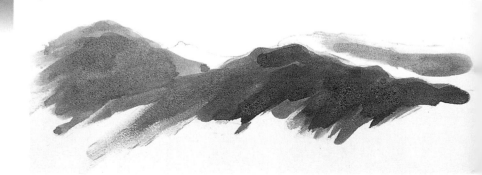

2 As the ink dries, build up darker layers on top, then dry your finger and use the next strength dilution to draw the hill in the middle ground in the same way, pulling the ink across the paper enough to show the distinction caused by aerial recession. With a weaker dilution, start on the right-hand hill.

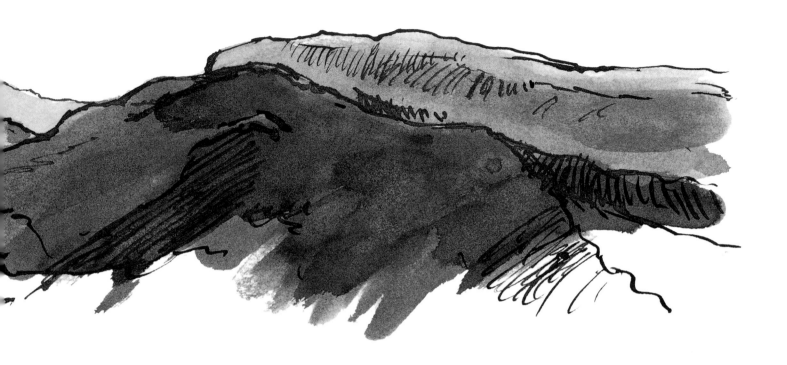

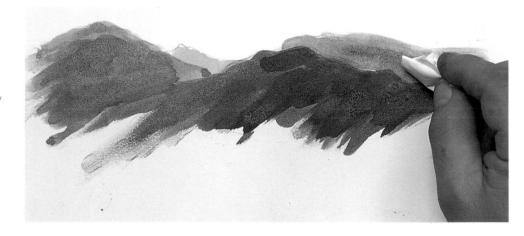

3 **right** Before you start using the weakest-strength dilutions, test each one on a scrap piece of paper and adjust the strength if required – it is better to make many small applications than one large one that cannot be rectified. Use a piece of clean tissue paper or cloth to dab any excess liquid off the surface; you can also use this to spread the ink further across the drawing.

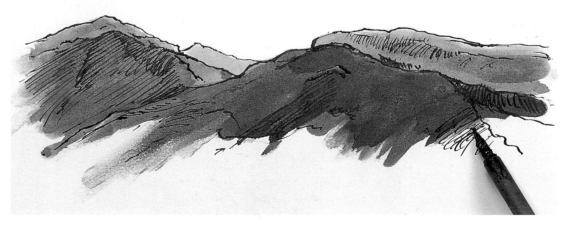

4 **left** With the shapes established, use a pen and the full-strength ink to draw in the details – the outlines of the hills and the textural marks – following the directional marks made with the finger. Apply the pen marks loosely, and avoid the temptation to overwork the drawing or lose its freshness.

Scale

The dictionary definition of scale is '... relative magnitude or extent; degree or proportion...', and there are a number of ways in which you can convey the relative sizes of hills and mountains. Perhaps surprisingly, getting in close is not one of them – our sense of scale and perspective is distorted by excessive proximity, and we are more likely to feel claustrophobic if there is nothing between us and the mass of a mountain.

For this reason, a sense of scale can usually best be described from a distance. Looking for an asymmetric view can also be useful, because too much regularity can lead to a feeling that the scene is man-made, or at least regulated by human intention. The inclusion of a figure, animal or building, dwarfed by the sheer size of the mountains behind and around them, instantly creates a sense of scale, as can be seen in the drawings below and opposite above. A low viewpoint will also add to the sense of towering height.

You can also choose idiosyncratic viewpoints and scale to make a particular point: the 19th-century German painter Caspar David Friedrich (1774–1840) would position crosses so that they seemed larger than the surrounding mountains, thus showing his belief in Christianity. But think carefully before going down this path, as distortion is rarely successful for its own sake or as a technical trick.

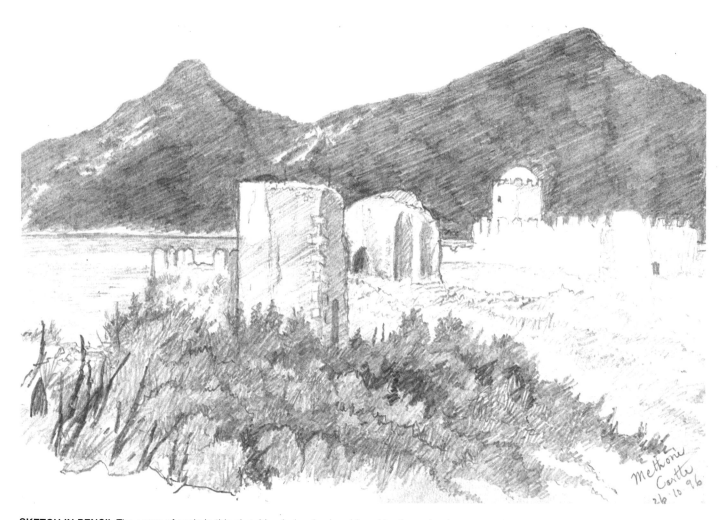

SKETCH IN PENCIL The sense of scale in this sketchbook drawing is achieved by three drawing techniques. The vegetation and buildings in the foreground are drawn with a fair amount of detail (the individual grasses and indications of corner stones in the tower); the buildings in the middle ground are left as negative shapes; and these contrast against a solid mass of lowering hill shapes in the background.

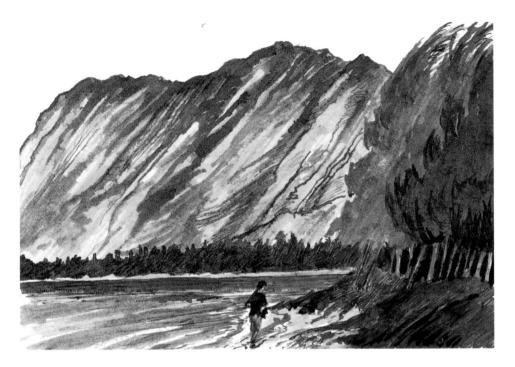

SKETCH IN NUT BROWN INK

Including a human or animal figure in a drawing is a quick way to indicate scale. Here, the figure is drawn in the foreground from a viewpoint slightly above the head; any changes in the composition – putting the figure farther away, drawing from higher up or below – would affect the viewer's immediate response to the picture. Full-strength ink was used only on the figure and for the shadows between the trees on the right, emphasizing their closeness to the viewer.

SKETCH IN WATERCOLOUR PENCILS

The massive quality of the mountains in the background is intensified here by the use of colour: the warm tones of the flowers in the foreground are echoed in the hillside on the middle left, before the strong, layered tones of the mountain overwhelm these with a cold colour temperature. The distance across the field to the tallest trees makes the size of the mountain even more impressive.

TIPS

■ *Reference photographs are very useful when it comes to deciding how to choose to depict scale; photo libraries and catalogues often include unusual and unexpected views and viewpoints.*

■ *You can use the techniques described here to suggest a sense of scale in an urban townscape as well; the perspective of buildings and man-made objects is another invaluable aid.*

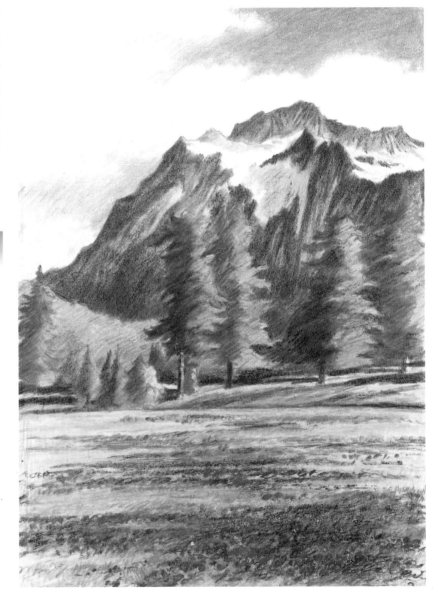

Hilltop views

It is one thing looking up at hills and mountains from below or from halfway up; it is quite another once you reach the summit and look down or around, and the change in viewpoint means that familiar features of the landscape take on new shapes when seen from on high.

Any view from the highest point of a hill or mountain will make the sky a major part of a composition, perhaps with clouds occupying a lower part of the sky area than when seen from ground level. Seeing so much more sky means that you should take care to capture any variations in colour that result from your observation. Where you choose to

place the horizon line in a drawing is also important: a low horizon emphasizes the relative height of the hilltop, while a higher one gives the impression that there may be other hills around.

If your view is similar to the drawings below and opposite, where there are no other hills or high points to be seen, you will notice that the effect of aerial recession and colour temperature is not as dramatic or as sudden as when there are mountains in the distance. It is there, nonetheless, and you have to ensure that the subtle gradations and changes are credible and true to life.

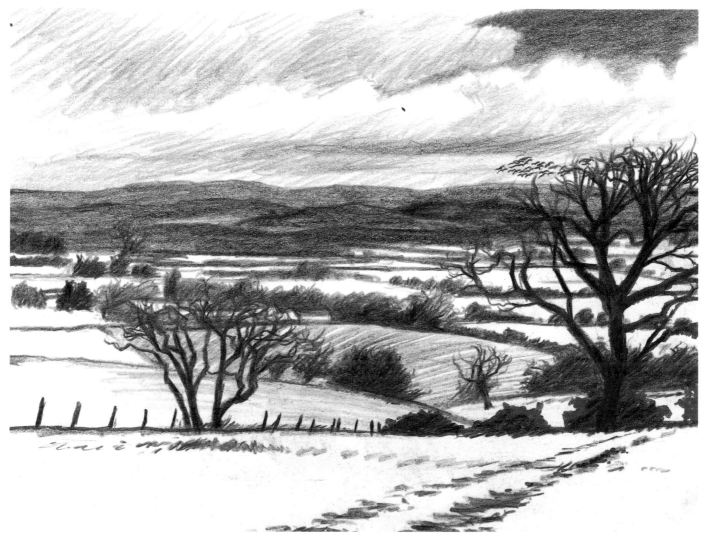

VIEW FROM THE TOP IN WATERCOLOUR PENCIL Making a monochrome sketch, such as this one in burnt sienna watercolour pencil, is a good exercise in creating gentle aerial recession. The right-hand tree and the flock of birds beyond it are placed at eye level, indicating the height of the hill in the foreground.

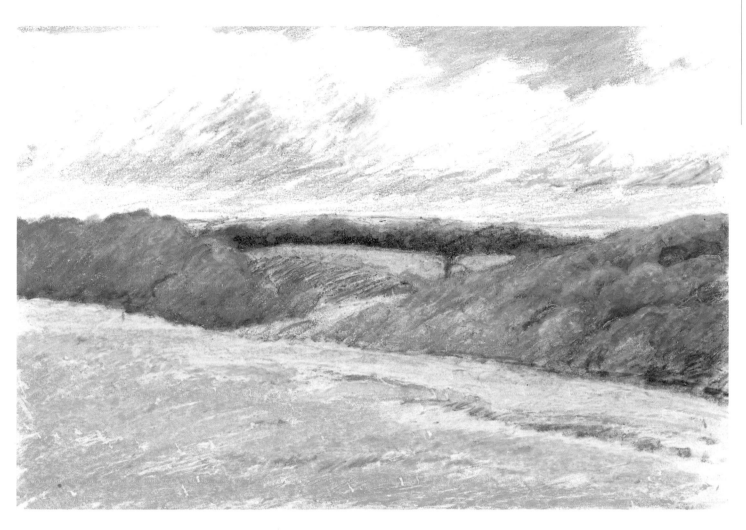

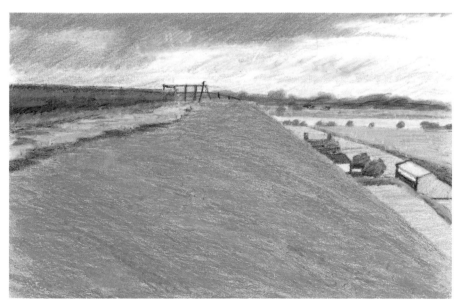

**VIEW ALONG THE TOP IN WAX CRAYONS
AND OIL PASTELS** The vista may not be quite
as dramatic as that in the drawing opposite, but
this sketch gets its effect of being on high
ground from the gentle contours in the
foreground. The light on the clumps of trees
comes mostly from above, not reflected off the
ground, and the gap between them leads to a
field too far away for any details to be seen.

VIEW FROM NEAR THE TOP IN MIXED MEDIA Making the side and top of a hill the
foreground in this sketch is a bold move, as no indication is given about what lies on the
other side of the hill top. The buildings and trees on the right show how high the hill is,
as does the height of the fence at the top, reaching above the horizon line.

TIPS

■ *Take your time when choosing a view from
the top of a hill – the first one you see
may not have as much to recommend it as
one glimpsed in a second look.*

■ *Even on a still day at ground level, there
can be strong winds at the top of a modest
hill, so take along a weighted bag or
heavy sticks to prevent an easel flying
away or toppling over (see pages 36–37).*

'Don't be timid in front of nature; one must be bold, at the risk of being deceived and making mistakes.'

CAMILLE PISSARRO (1830–1903)

Wide open spaces

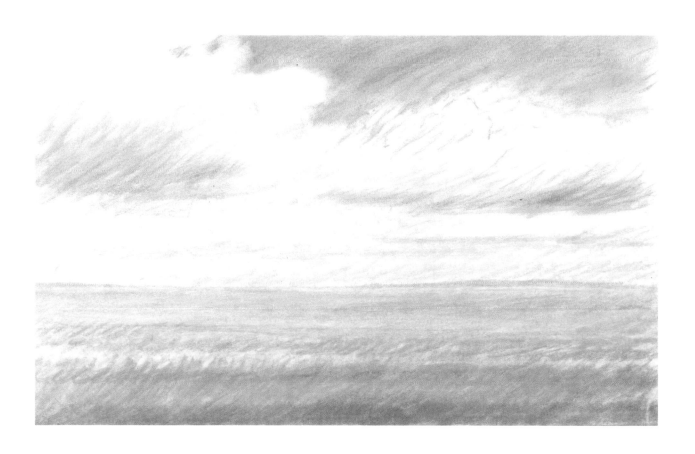

Deserts

Although they might seem strange, bleak subjects to draw, in fact there is a great deal of variety in deserts, from the undulating, rippling, shadowed sand dunes of the Sahara to the faraway surrounding mountains of Death Valley.

For this study of the famous lithic stones in Monument Valley, Arizona, USA, I decided to work mostly in pastels, with wax crayon for the establishing marks and pen and ink for a few fine details, all on off-white paper. By not over-working the amount of pastels you put on the surface, you can blend the dust to an almost transparent layer that you can then add to and blend further for very subtle gradations of colour that suggest the contours of the desert.

The sizes, distances and proportions in this area can be deceptive – the monuments are far larger than you imagine, so the distant hills are a very long way off, thus intensifying the effect of aerial recession (see page 56). The sheer size helped me decide against adding figures or a vehicle for contrast, since they would be all but indistinguishable.

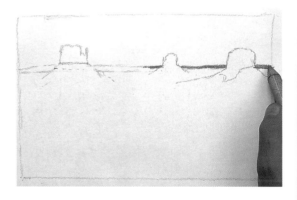

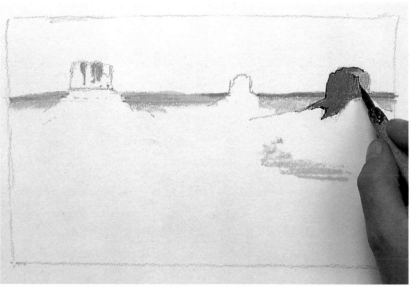

1 **above** Use a Vandyke brown crayon to draw in the basic shapes lightly – the lithic stones, the high horizon line and the distant contours. Concentrate on the outlines and proportions, then use a purple tint 2 pastel for the far desert, softening and blending the dust with a torchon.

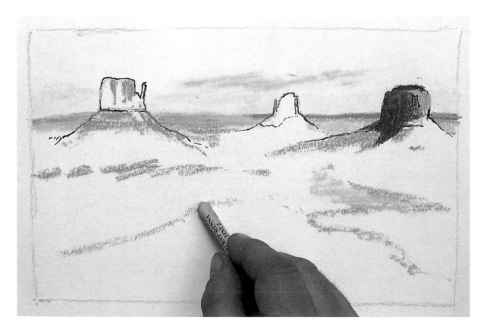

2 **above** Add cobalt tint 0 pastel on the horizon, then blend it with more purple. Apply burnt sienna tint 2 beneath this, and use it for the base of the monument stones. Add Vandyke brown tint 4 for the darker areas on the stones, and blend it to solidify. Use pen and sepia ink to draw the outlines and vertical shapes on the right-hand stone.

3 **left** Add the darkest colours to the right-hand stone with Vandyke brown tint 6 pastel, then draw in the other stones with pen and ink. Introduce white pastel into the sky area, and draw over it with a few light strokes of the cobalt pastel. Start the colour at the base of the stones and suggest faint contour lines in the middle and foregrounds using burnt sienna tint 2 pastel.

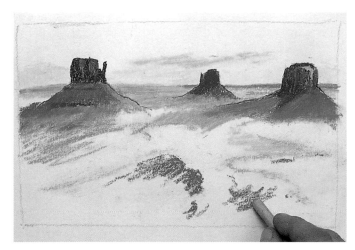

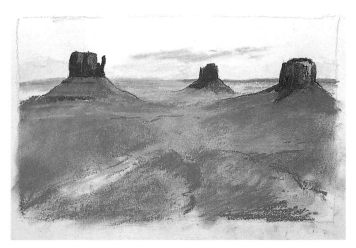

4 Fill in the colours on the other stones as before, then add red-grey tint 4 pastel for the darker desert sands that lead down to the floor of the valley. Blend burnt sienna tint 2 into this and soften with the torchon, then repeat this process with burnt sienna tint 4 pastel as you come nearer to the foreground.

5 Use the side of the pastel stick quite hard before blending the dusty desert tones together with your fingers, the side of your hand and a torchon. When the shapes are formed draw into them with the lighter burnt sienna tint 2 pastel. On the sides of the bases of the stones add a little purple tint 2 pastel to echo the far distant colour, then blend this.

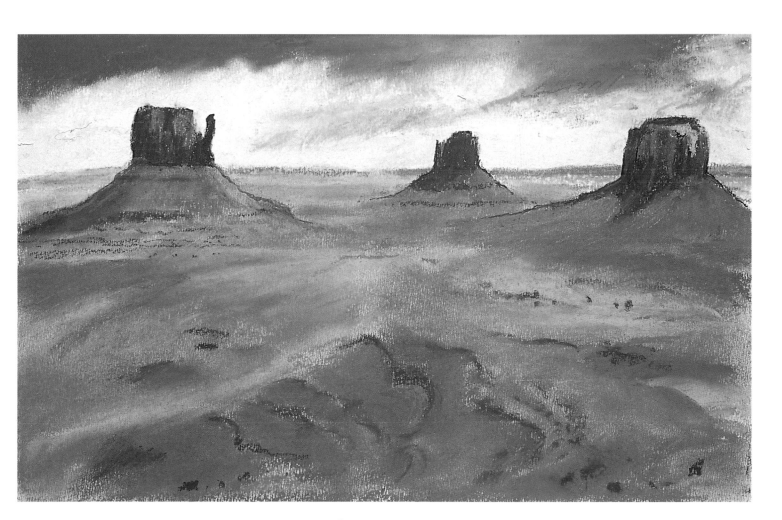

6 Use Vandyke brown tint 6 pastel to pick out the dark contours and ridges, following the shading. To pull the drawing together and impose a sense of unity, add burnt sienna tint 0 for the lightest sandy patches, red-grey tint 4 pastel for the mid-colours, and a few small stones in Vandyke brown tint 6. Finish the sky by adding ultramarine tint 4 pastel at the top, blending it to tone it down, then cobalt blue tints 2 and 0 for the lighter blue near the horizon.

Prairies

Having stated that there is a great deal of variety to be found in deserts (see page 64), the reverse is pretty well true when it comes to drawing prairies and other vast, flat, open spaces. It's no wonder that Dorothy found the Land of Oz so different from Kansas – anything less than huge, wide skies and massive field after massive field of crops would strike her immediately as claustrophobic and odd.

This sheer lack of defining features in a prairie view – even the occasional feature, such as a barn or farm building, does little to change the overall effect – presents the artist with quite a challenge: not only how to capture the size of the area, but also how to find interest in such uniform colours and shapes.

Obvious though it may seem, consider working on a large piece of paper to suggest the size of your subject. A long, wide landscape format automatically makes the eye search from side to side, and the lack of an instantly recognizable, single focal point brings the gaze to the farthest horizon, intensifying the effect of distance.

If the land is seen wide, then so too will the sky. You can reinforce the sense of space by applying the rules of aerial recession (see page 56) to the colours in the sky, using cooler, paler colours in the distance, and layering the clouds as they recede. Prairie lands can be subject to sudden and dramatic weather conditions, such as tornados and whirl-winds (remember Dorothy), and you can use reference photos to look at the effects of these on prairie scenes – I definitely do not recommend trying to paint a cyclone or tornado on location!

TIP

■ *Even under cloudless skies, the colours of crops and grassland on prairies are never uniform, and you need to be able to show effectively the subtle change from warm colours in the foreground to cool, pale ones in the distance. Practise building up layers of colour, blending soft media such as pastels, and working lightly with harder media, such as watercolour pencils.*

PRAIRIE IN PASTEL PENCILS In such a flat, featureless scene, any interest must be created by the use of colour and the subtleties of tone and warmth. This study began with the lightest colours of the land – Naples yellow and lemon yellow – with the darker shades added gradually across the whole picture. The nearest foreground and the top of the sky were applied last of all.

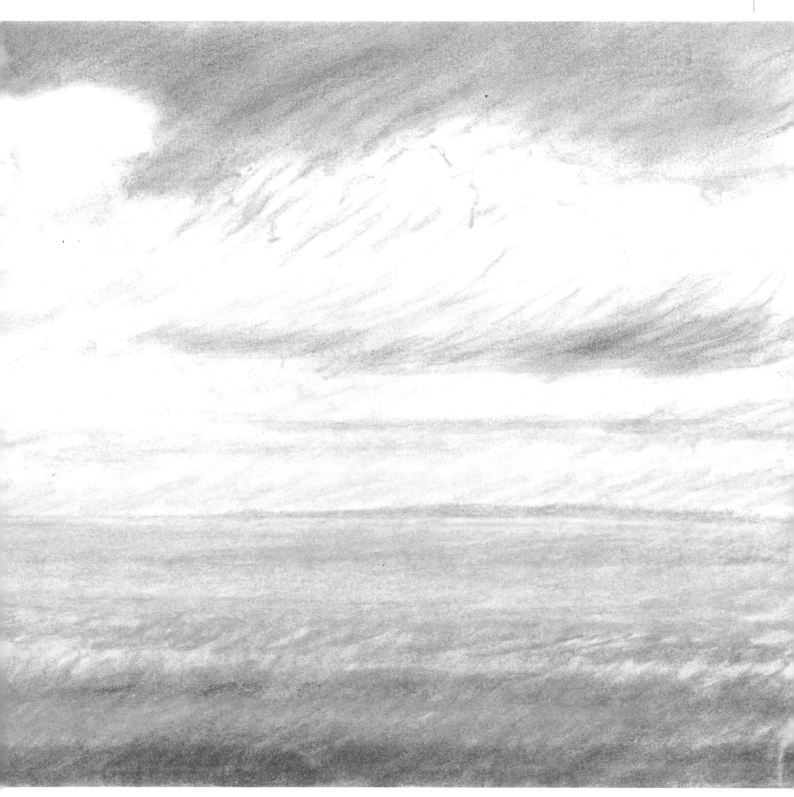

Moorlands

Of all the types of wide open spaces you are likely to draw, moorlands are the most varied and changeable, because the climates where they are found are subject to the widest range of weather conditions – from blazing sunshine to blizzards, via all kinds of rain, sleet, mist and fog.

There are also many variations in natural colours to look for – the rich purple of heather often accompanies quite lush grassland, while the bright yellow of gorse flowers can be allied to a parched brown on the bare hillsides. Keep an eye open for marshy or boggy ground, as the vegetation there is likely to be darker overall than elsewhere on the moor.

The effect of your drawing will depend greatly on your viewpoint (see pages 14–15), and it can be interesting to make a number of studies of moorland scenes from slightly different viewpoints, and under different weather conditions, before embarking on a single, definitive drawing.

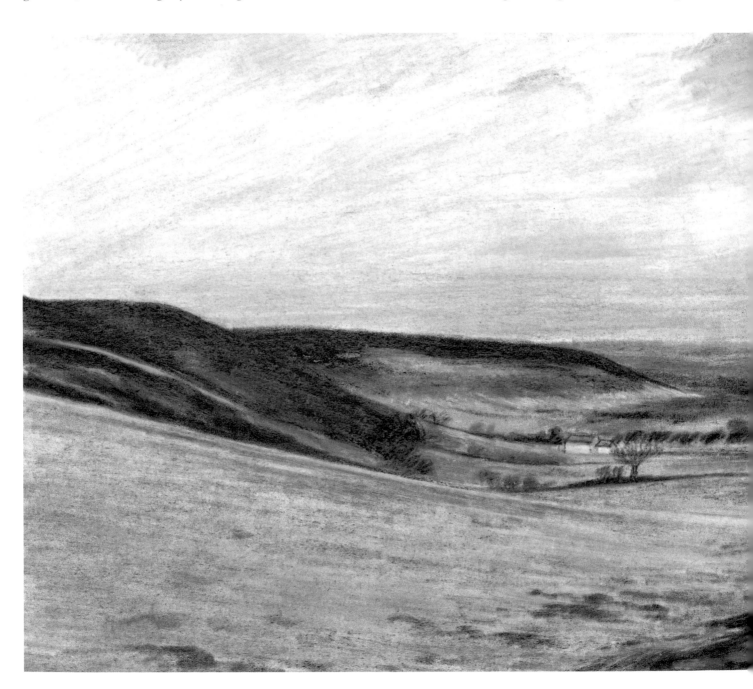

**PRELIMINARY SKETCH IN BALLPOINT
PEN** This first sketch of the view below was
useful for two reasons – first, to help decide
which parts of the composition could be kept
or adapted, and second, to establish the
shapes and tones. Working in monochrome
means you have to concentrate on using only
the bare essentials to provide information
about a scene.

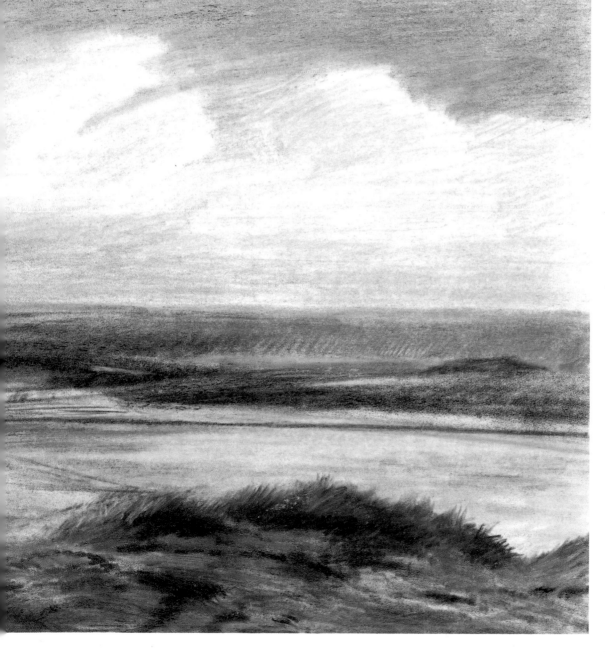

**MOORLAND IN
WATERCOLOUR
PENCILS**
This view takes its
strength and interest from
the repetition of shapes
and colours across it. The
deep blue-purple of the
hills on the left is repeated
more faintly just below the
horizon line, and the red-
brown of the near right-
hand clump is repeated
behind it in the middle
and far grounds. All the
colours of sky and land
find some reflection on the
undersides of the clouds.

'Learn to draw well and appreciate the sea,
the light, the blue sky.'

Eugène Boudin (1824–1898)

Water

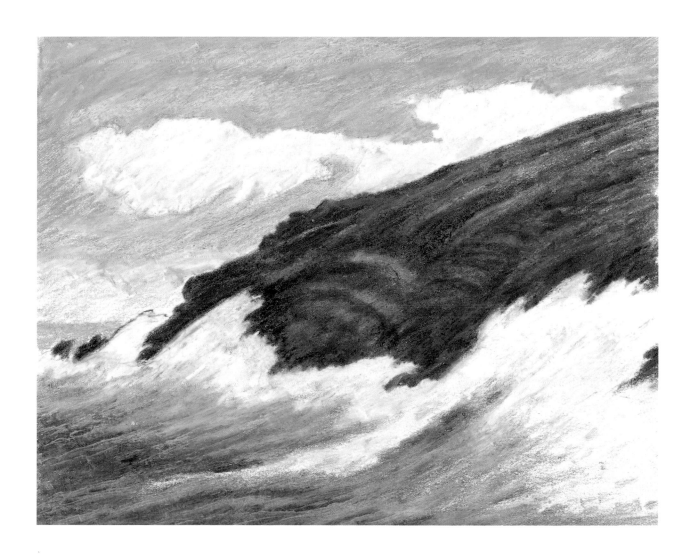

Still waters

Slow-moving or completely still waters seem to pose more problems for the inexperienced artist than fast, rushing rivers or cataracts; this is usually because the temptation is to treat the surface as a solid plane that only reflects what lies above it, without considering the volume of water and objects below the surface. Unfortunately, without some thought and observation of this kind, it is difficult to achieve a believable flat effect without looking false and clichéd in a chocolate-box way.

What does a stretch of still water say about the scene? There is obviously no wind or rain to disturb the surface, so you need to keep this feeling of stillness in the surrounding areas, from trees to single grasses growing at the water's edge. However, still water in the foreground can be allied to objects on the far background surface: the ripples from a moored boat or resting duck will break the smooth plane of the water, and the wake of distant boat on a large expanse of calm water will suggest activity far away.

BEND IN THE STREAM IN PENCIL AND GRAPHITE In this sketch, the viewpoint was carefully chosen to bring out the myriad of reflections in the water – both the left- and right-hand banks can be seen as dark reflections, as well as the lighter patterns created by the sky and clouds. Monochrome studies help you to concentrate on the essential elements.

Practice exercise: **Puddle in watercolour pencils**

'One may not doubt that, somehow, good/Shall come of water and of mud', wrote the poet Rupert Brooke, and this exercise is a study of a very small area of still water that manages to encapsulate the same challenges and solutions you would face in drawing a large, placid lake or pond. Even in miniature, the reflections of the sky in the water are essential, and the tones and colours of the land surrounding the water can be used to set the scene from the outset – and such a small expanse of water is unlikely to be disturbed by birds, windsurfers or boats. For this exercise I used watercolour pencils on white paper, but did not use pure white for the clouds.

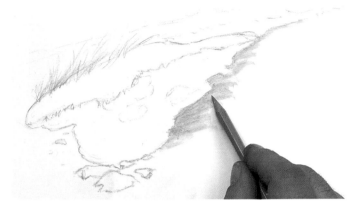

1 Work lightly with burnt umber to establish the shape of the puddle and the edges of the ground, not forgetting to draw in the shapes of the cloud reflections in the water. Add some of the pebbles under the surface – these will be refracted by the water. Use a little may green to indicate the colour of the surrounding grass.

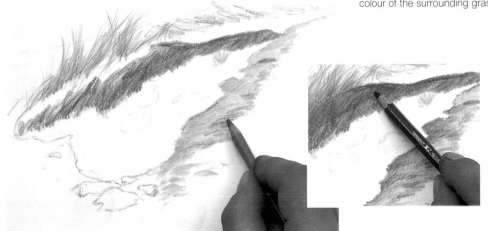

2 Draw the tufts of grass poking out of the water with the may green, then put in the earth and main reflection at the top of the puddle with terracotta. Use sepia to enhance the reflection, and bring this onto the bank. Use olive green for the dark reflections of the green, and mineral green for the grass on the bank. **Inset:** Use caput mortuum to dull the browns and reds, both actual and reflected.

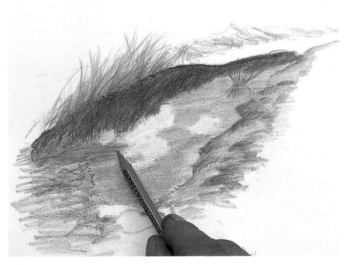

3 Use cerulean blue over the reflected sky in the puddle, then a little caput mortuum for the bottom of the puddle, working around the cloud shapes. Lightly add cobalt blue for the sky, and a touch of flesh pink on the clouds. Blend and soften the blue with white. Strengthen the puddle and grass colours, and add light violet to the darkest parts of the water.

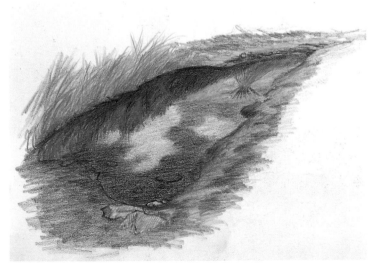

4 Bring the cloud tone together with very light touches of light violet, and reduce the starkness of the foreground stones with flesh pink. Reinforce the earth with burnt sienna and burnt umber, the grass with light yellow-green, and the sky with blue violet lake and imperial purple. Use burnt umber to sketch in the stones at the bottom of the puddle.

Moving waters

The movement of water is a fascinating subject, from the gentle disturbance and ripples caused by a fish breaking the surface, or a gentle breeze, to storm conditions forcing the water into waves and dramatic shapes. It is difficult to capture this movement on site, but look for repetitions and patterns in the water. Just as with still water (see page 72), rocks and ground under fast-moving water and even water-falls will be affected by the depth and speed of the water and will not be a uniform colour or tone.

For the waterfall exercise here I used watercolour pencils on tinted grey paper – you can manipulate the white of the spray and foam more effectively on a toned ground than if you try to colour it in on white paper. Working from light to dark means that you can build up and reinforce the tonal contrasts with confidence, knowing that the lightest areas stand out more as you darken the rest.

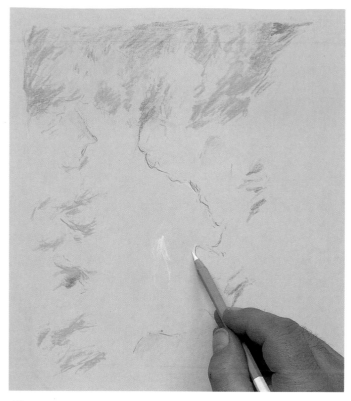

1 Establish the shape and position of the trees in cedar green, and start the sky colour with cerulean blue. Add a little may green and then olive green to the tree areas, shading gently. Use flesh pink for the highlights on the mountains and the rocks, then start the water with Chinese white.

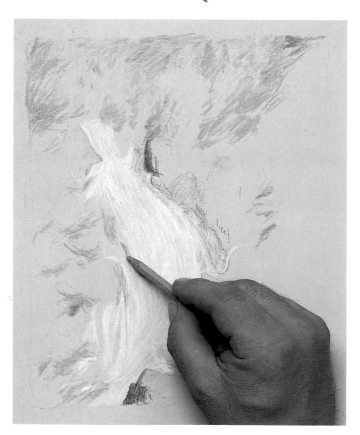

2 Use short strokes of Chinese white for where the water meets the green banks, and longer strokes to show the fall – aim to follow the course of the water, even if you can't see the rocks and stream bed beneath. Add a little caput mortuum on the near foreground rock and at the top of the water, then apply more white around and over it.

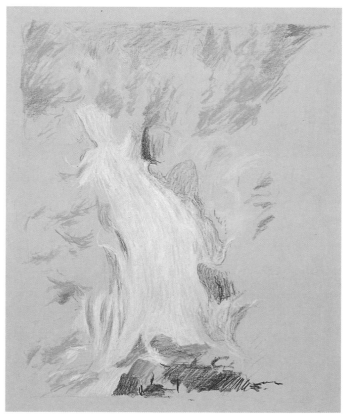

3 Use gunmetal grey to start the darker water areas, again following the fall, and add kingfisher blue for the reflection of the sky – each time, go back to white to keep the unity of the water. Use long lines of ochre for the rocks on both sides of the water and at the bottom. Add some flesh pink, both on the rocks and in the reflections in the spray.

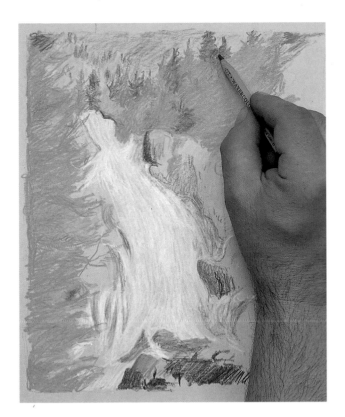

4 With the water established, use straw yellow over the green to show the effect of sunlight, then build up the foliage with may green, blocking it up to the edge of the water and accentuating the white foam. Work over the surrounding areas with cadmium yellow and then cedar green, interspersing these with grass green and mineral green to capture all the hues of the different trees.

TIP

■ *Use loose, fluid and directional strokes and marks to portray the ceaseless motion and activity of water – trying to be over-precise can lead to a stilted; static effect.*

5 Use the mineral green to pull the whole composition together, and to create the shapes of both the light and dark trees. To establish the very darkest areas, start with free, scribbled marks of Prussian blue and then overlay these with dark violet, tightening up these colours with more pressure as you go. Boost the wooded areas with applications of brown ochre, sunny yellow, burnt sienna, burnt umber and spectrum blue, remembering all the time that the white of the falling water is the focal point, and looking to bring out the contrast with the surroundings. Reinforce and boost the white, but be careful not to overwork this and lose the vitality of the scene.

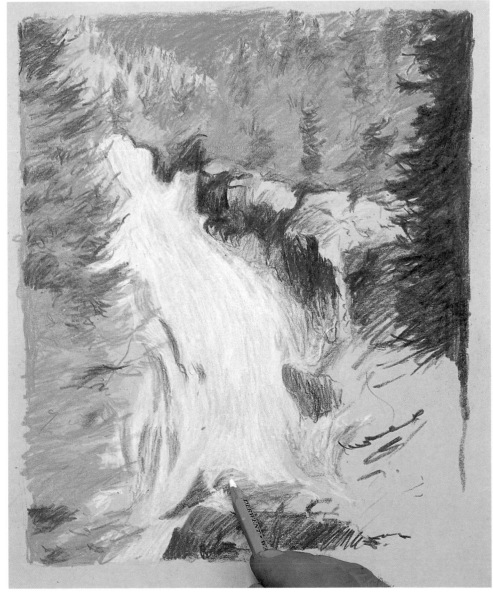

Reflections in water

Possibly the most intriguing thing about reflections in water is their existence in a strange never-never world – we can see them and, as artists, draw them, but at the same time they are two-dimensional and intangible, with less 'stability' than a reflection in a mirror. This fleeting, transitory nature requires careful observation and lots of sketches and studies if you are to use reflections positively in your work.

Look carefully at the light quality and its direction – working *contre-jour* (against the light) can lead to some stunning views in which the reflection of the sun or moon is the focal point of the picture (as shown on pages 96–101). In addition, practise the kinds of marks that can be made to capture reflections, and use a variety of media to do this – drawing with unfamiliar tools can help you to reassess how and why you work with the ones you are most comfortable with, and can lead to unexpected effects.

QUICK STUDY IN PENCIL Where a reflection is close to being the exact same shape as the object, use varied types of marks to point out the differences – here, the long strokes that make up the rock contrast with the short, jagged marks of the reflection in disturbed water.

MOORED BOATS IN WATERCOLOUR PENCILS In this sketch, note how the reflection of the pillar on the left is appreciably darker than the pillar itself, as well as a colder green colour; the reflected hulls of the boats are darker too. Including a vertical mast and its reflection shows clearly how much even a little amount of movement in water can refract and break up reflections.

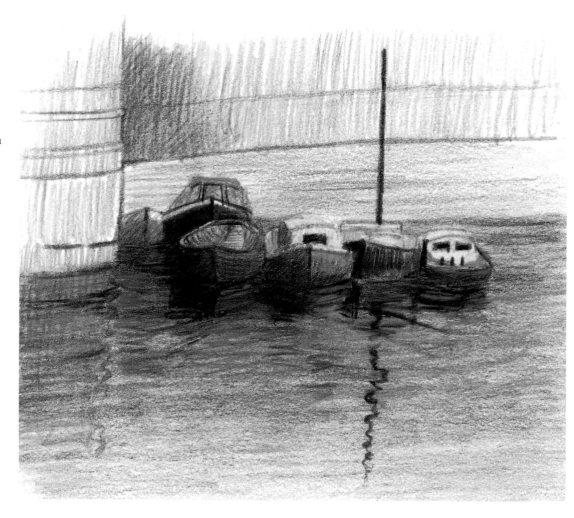

TIP

■ *When using pencils, a good way to capture fleeting reflections in watery on location is to prepare two or three pencils of the same grade beforehand – one sharpened to a point, one with a slightly blunted point, and one cut to a wedge shape with a square tip. This way, you can select each pencil as required, and make quick marks that keep the freshness of the scene before you.*

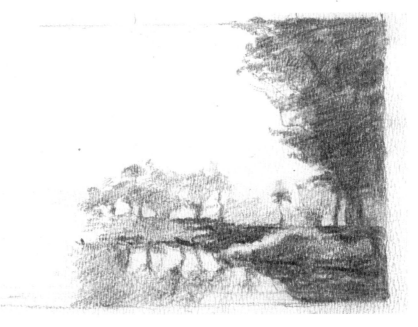

COUNTRY SCENE IN PENCIL You can portray reflections very effectively without having to go into too much detail or rendering the reflections exactly. In this quick sketch, the light marks of the leaves on the trees on the left have a counterpoint in the water, with only the trunks serving to fix any shapes.

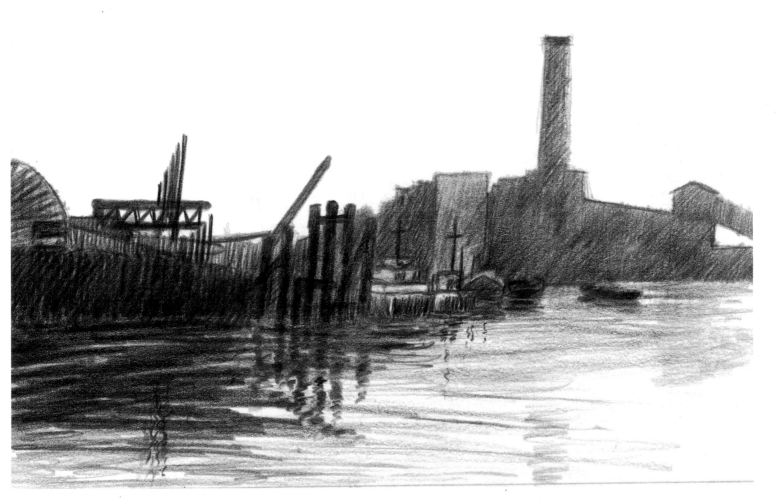

URBAN RIVERSCAPE IN WATERCOLOUR PENCILS Riverbanks crowded with industrial buildings and machinery can produce some fascinating reflections, from the dark, intense marks on the left to the reflection of the tall chimney on the right, which is faint because of the distance it has to travel before being seen on the water.

Coastal scenes

Artists seem always to have been attracted to coastal areas – think about how many artists' groups have been established in towns or villages with easy access to the sea – partly because of the variety of moods and atmospheres that can be found within a relatively small area, and partly due to the changes that can be seen and drawn throughout the year.

Coastal scenes offer many different subjects and viewpoints: you can turn 180 degrees from a wild, untamed view and find a beach resort, which offers up a completely differ-

ent interpretation. (Working on one view and then straight onto the other is unusual, but might well be worth a try.) You may find a portrait format more suitable for studies of cliffs, or choose to crop in on the textures of pebbles on the beach. You also have the choice whether to include figures in a coastal scene – the drawing opposite below uses a couple to show the distance from the foreground to the background, while the drawing on this page allows the viewer to decide on the scale of the land and breaking waves.

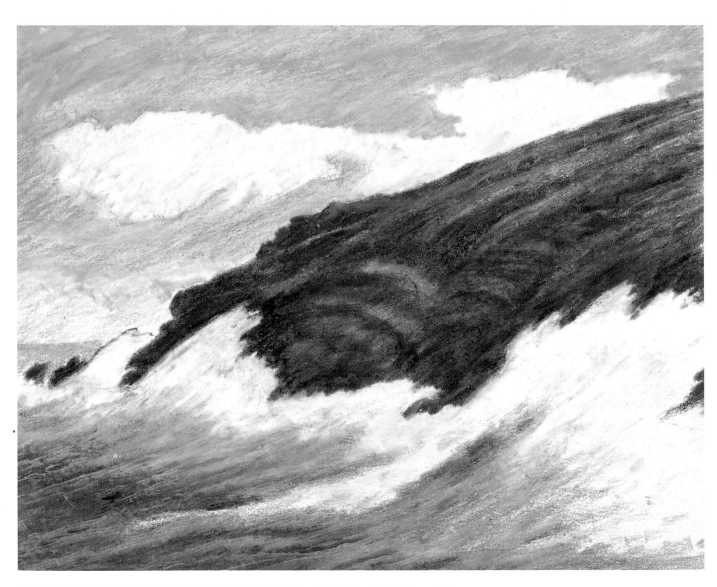

WILD WAVES IN WAX CRAYONS AND OIL PASTELS Selecting the right medium is important for capturing the force of crashing waves– the soft quality of wax crayons and oil pastels makes them ideal for capturing both the energy of the incoming sea and the contours and colours of the land. Make sure the foam follows the same direction as the bulk of the waves.

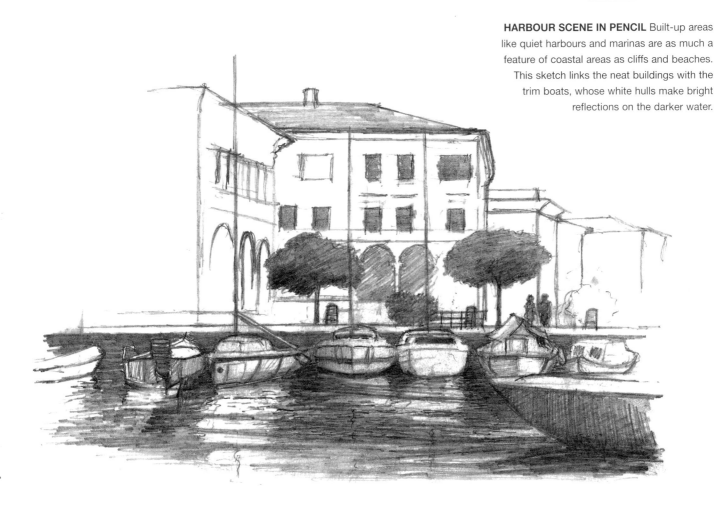

HARBOUR SCENE IN PENCIL Built-up areas like quiet harbours and marinas are as much a feature of coastal areas as cliffs and beaches. This sketch links the neat buildings with the trim boats, whose white hulls make bright reflections on the darker water.

BEACH AT LOW TIDE IN BALLPOINT PEN AND FELT-TIP PEN
The stones in the foreground lead the eye in a zigzag man-made path to the dark breakwater in the background, with the fence posts and a few tall masts on the right echoing the low verticals on the breakwater. Ballpoint pen was used for the lines and cross-hatched shadows, while the darker, more solid areas were blocked in with felt-tip pen.

Open seas

When you think about paintings and drawings of open seas, which artists come to mind first? To take extreme examples, Turner's dramatic, colourful seascapes and experiments with light contrast with the turbulent, always movement-packed works of Len Tabner; and then there are works that concentrate on the craft that travel on the seas, with the sea itself playing a more supporting role. Each interpretation is exciting and valid, and this choice of treatment makes many artists turn their back on the coast and seek a new horizon to broaden their repertoire.

Unless you are trying to capture stormy, wild seas – which have an unpredictable quality that demands bold, bravura statements – it is a good idea to practise drawing the regular patterns that are made by waves and troughs; use a camera to freeze the movement, and link photos with your own studies from life. Don't rely on a camera to record the colours of the sea, however; make studies and notes in a sketchbook.

Once you start to develop sea sketches and studies, it quickly becomes clear that you must combine any exploration of the water with work on the sky – whereas you can choose a viewpoint with a high horizon on land, it is far more difficult to adopt the same procedure effectively on the open seas. Utilize the advice and information on skies on pages 39–51, and then look for how you can achieve unity between the elements in a seascape.

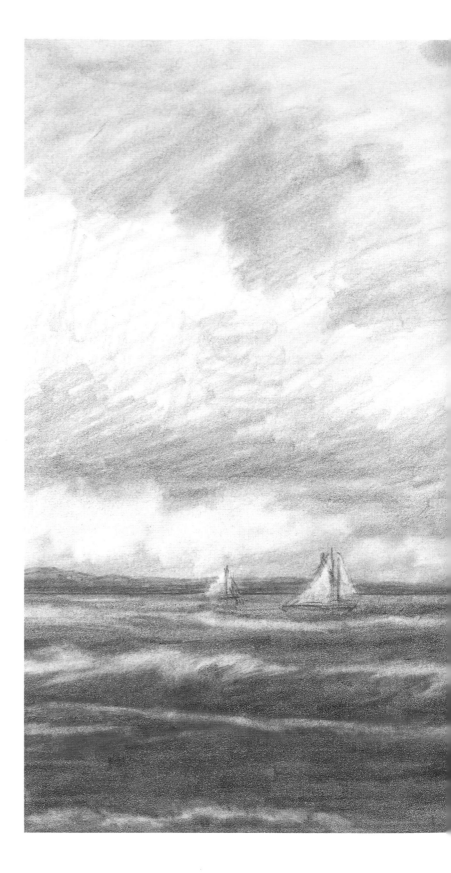

TIPS

■ *A video camera is extremely helpful for seeing regularity and patterns in waves – but be careful not to let salt water get into the lens or body, as it will spoil and corrode the camera.*

■ *Boat trips can be very useful for studying sea and wave colours – the latter are not always white.*

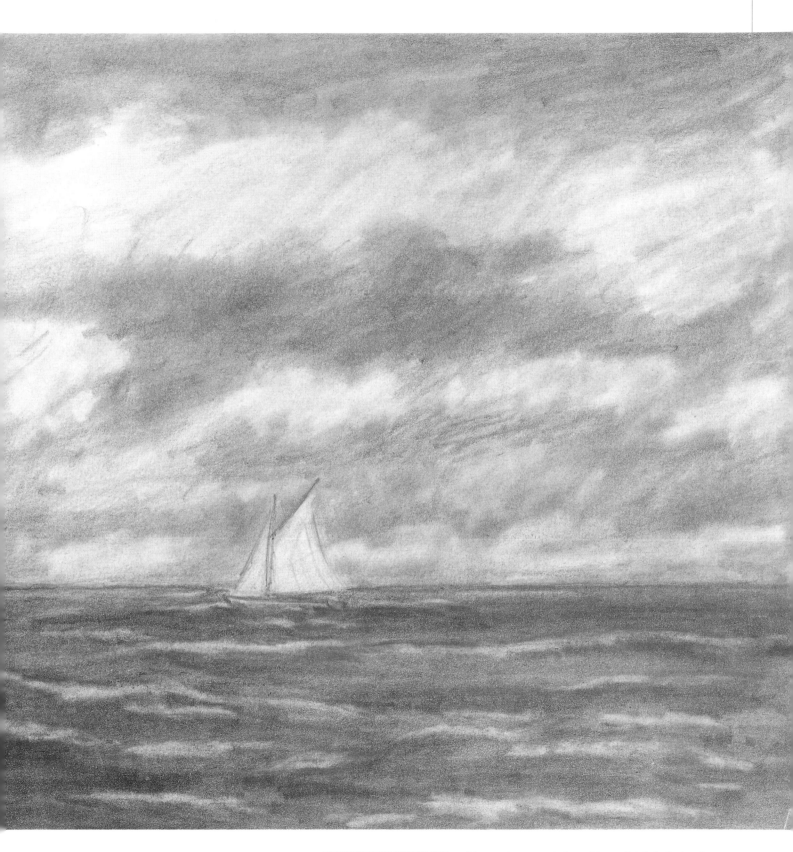

SEASCAPE IN PENCILS The wide, semi-panoramic format immediately indicates the openness of the sea, while the sailing yachts and the white horses on the tops of the waves show that there is some wind. The horizon, sky and boats were drawn using HB and 4B pencils and a torchon. The dark sea tones were drawn with a soft 9B pencil, the foam was lifted out with a cut wedge of soft kneaded eraser, and the clouds were drawn in the graphite with a broad eraser.

'A tree full of colours… the colour isn't on the leaves but in the empty spaces… a painter can't be great if he doesn't understand landscape.'

PIERRE AUGUSTE RENOIR (1841–1919)

Trees and woodland

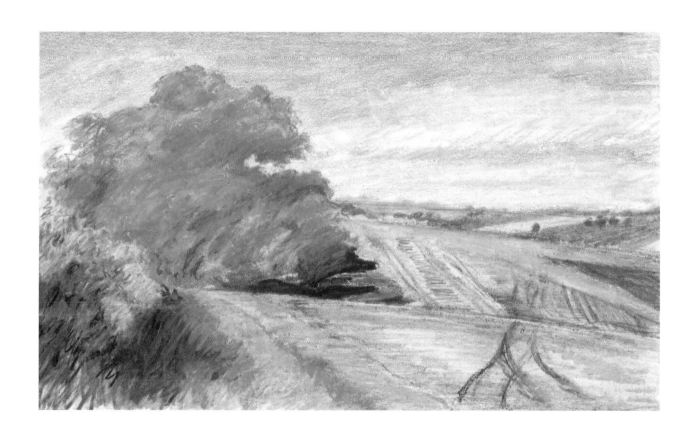

Shapes and structures

Seas, prairies and deserts aside, most landscapes feature trees. They are a very important factor in compositions, as they can provide vertical lines and direction to an otherwise flat picture, and they can be used to bring colour, texture and pattern into a composition as well.

Even if they are only in the background, trees should be drawn accurately, and to do so means learning something about tree structure – the angle at which the branches come out of the trunk, for example, or the way the roots of some trees meet the ground and go into it. As twigs and smaller branches grow, they become progressively thinner as they get farther from the main trunk.

The shape of a tree should also be uppermost in your mind when drawing its shadow – if there is no connection between the substance and the shadow, the drawing will look awkward. Tips for drawing masses of foliage are given on page 86, but it's important to mention here the shadows that are found in the foliage, which are a useful aid to discovering where the main branches are; in full-leafed deciduous trees, they can be considered in the same way as contour lines, with the lines often picked out as highlights.

TIP

■ *The studies on the right show a selection of standard European and North American tree shapes in full leaf. The evergreens look the same all year round, but the deciduous ones shed their leaves and present a skeletal appearance in winter. Practise drawing single trees in different seasons – observe closely and do not make assumptions about the underlying structure of the trunk and branches.*

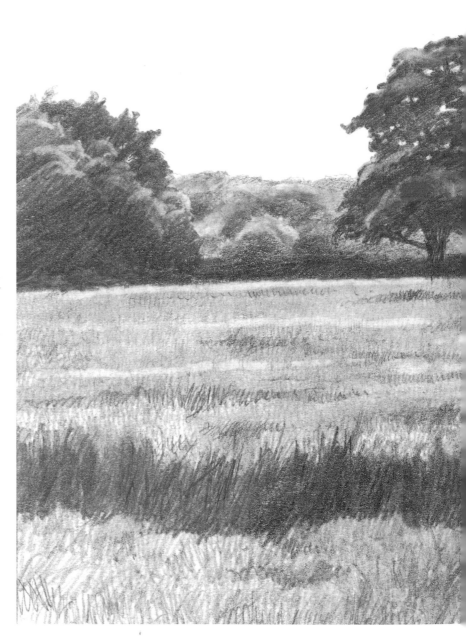

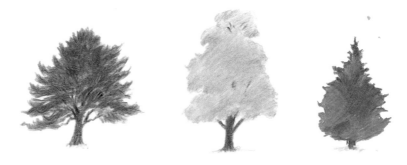

LANDSCAPE WITH TREES IN PENCILS Each of the trees in this drawing has a different shape, structure and foliage. To bring out these individual qualities H, HB, 2B and F pencils were used, and the highlights were picked out using the eraser on the end of one of the pencils.

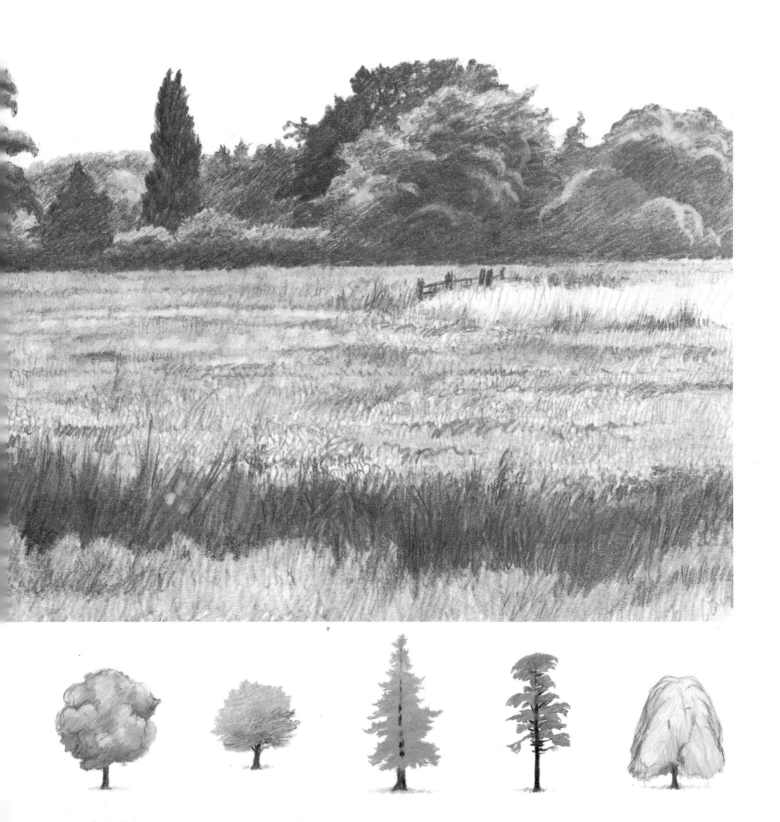

Masses of foliage

The 'masses' referred to here can be anything from a single tree in summer foliage, as in the studies on this page, to a whole clump, wood or forest of trees, as shown opposite. Either way, there are many ways to delineate foliage in an effective manner, and some of these depend on which medium you are using – building up layers of small marks in pen and ink or hard pencil creates an impression of great detail, while blending, softening and blurring soft graphite, charcoal and pastel marks is a good way to suggest trees in the distance.

Don't fall into the familiar trap of trying to make life easy for yourself by drawing each mass of foliage in a group the same colour or tone – this is never the case in nature, and it spoils any piece of work. Again, you don't have to draw each leaf, but look to give the viewer the idea that you did.

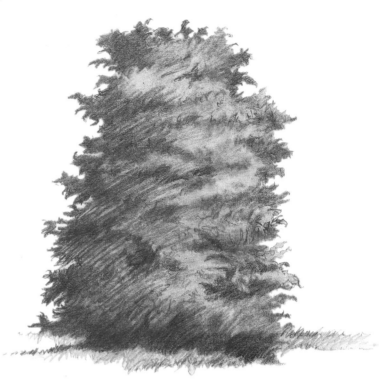

TREE IN PENCIL AND GRAPHITE PENCIL You can suggest a great deal by attention to a little detail. Here, the leaf shapes are only drawn in silhouette at the edges, with a very few picked out just inside, but the use of shading and contour lines gives an accurate and convincing impression of the foliage.

TREE AND HEDGE IN ROLLERBALL PEN Using a variety of marks is one of the keys to creating the feeling of lush foliage. Layering the marks creates light and dark areas in the trees and brings out the volume in them. Note the contrast with the spindly trees on the right, drawn with flowing lines as well as smaller marks.

Practice exercise: **Autumn foliage in mixed media**

Autumn in the woods of New England is legendary for the spectacular colours of the leaves, which seem to explode on the trees. Even when your eye is dazzled by the beauty, it's important to get the relationships of the colours right, rather than just putting on colour randomly. I used a pointillist technique on white paper, building up layers of colour from light to dark using pastels for soft tones with wax crayons and watercolour pencils for richer marks.

2 Working from light colours to dark ones, make circular and oval leaf marks with an orange crayon, and follow with an orange earth pastel. Build up the foliage mass with very small marks using spectrum orange pastel. Put in the grass around the trunks with may green pastel, then darken it with Hooker's green pastel.

1 Draw the trunk shapes in ballpoint pen and fill them in with brown crayon, leaving gaps for the leaf masses. Use a deep yellow cadmium pastel to mark in the lightest leaf colours, which show the bulk of the foliage.

3 Add the reddest leaves with a crimson red crayon, then use a green crayon for the remaining green leaves. Add dark orange watercolour pencil to give more shades, but do not be tempted to simply fill in the white gaps, look for the leaf shapes and shadows. Use raw sienna pastel for the colours behind the trees, then go over this with the leaf colours.

4 Work over the whole drawing at this stage, from yellow (light) through to brown (dark), looking to capture the shapes of the masses of foliage. Add cadmium yellow deep pastel and dark green crayon to the foliage and ground, still making small roundish marks, and lighten the ground where necessary with may green pastel.

Textures

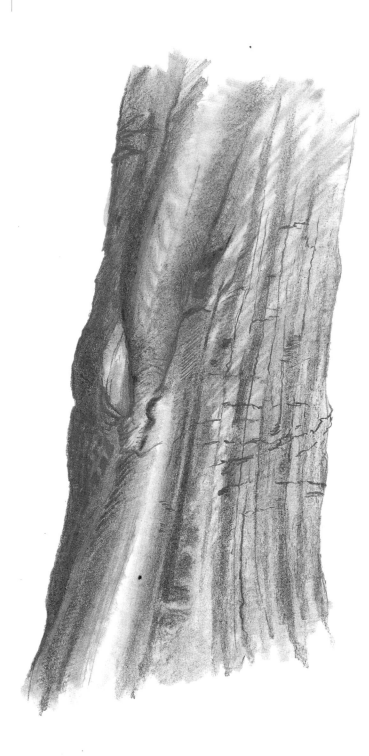

When dealing with trees, be it as masses in the distance or as close-up studies of a part or parts, capturing the texture is vital, as this, along with colour, shape and structure, is an essential building block to show character and individuality.

Getting in close, as in the study on the left, is an excellent way of sharpening your powers of observation, and of finding ways to delineate unusual surfaces and textures; and every type of tree has its own particular bark that repays study – the close, tight bark of a silver birch or rowan tree is poles apart from the rough, flaking bark of a London plane or the crevices and high points of a Scots pine.

You can also work on capturing the texture of a whole tree or group, as in the pictures opposite, and the texture here can be influenced by the support you use – a rough-textured watercolour paper immediately creates a stippled effect, useful for portraying distance and mistiness, while a smooth-textured drawing paper makes for more solid blocks of colour and tone.

Drawing bark or leaf texture close up also allows you to experiment with different media and methods. The Surrealist artist Max Ernst developed a technique he called 'frottage', in which he would place a sheet of paper over a piece of wood and rub over the shape with a soft pencil to bring the pattern of the grain out (rather as children do with coins, or as in brass rubbing). He would then draw into and over this pattern, erasing the areas he didn't wish to use. You can do the same, or use leaves for the veins, or even rub over man-made objects – a cork noticeboard gives a very interesting surface.

TREE TRUNK IN PENCIL AND GRAPHITE PENCIL For drawing this close-up view of tree bark a wide variety of marks and media was used – long strokes to suggest the direction of growth and the movement away from the vertical, short horizontal and diagonal marks to show the form and tone, and jagged marks to describe weathering and cracks in the bark. Both the tips and the sides of the drawing tools were used, the graphite was blended and pulled with a torchon, and the highlights were pulled out with a soft kneaded eraser.

TREES IN INK WASHES The different textures of the various foliage clumps are suggested here by the varying dilutions of ink used for each one. The leaves on either side are built up in layers to show volume and dense texture, while those on the middle tree are drawn with a single layer of wash, and are therefore lighter and with a thinner texture.

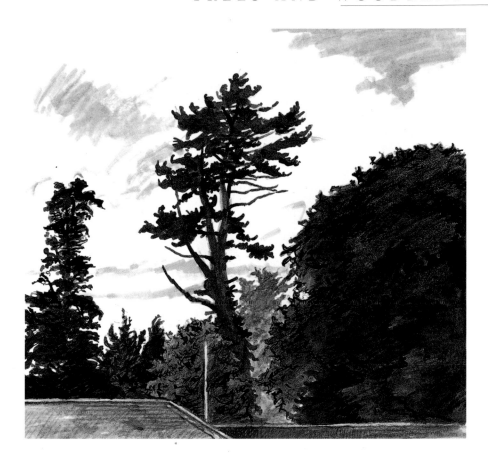

EGYPTIAN SCENE IN PENCIL The distant, 'far away' quality of this sketch is intensified by the texture of the whole drawing. Aerial recession (see page 56) is the key, but note how the feathery leaves of the palm trees in the middle ground are as muted as the most distant trees, but the trunks are drawn darker, bringing them forwards and establishing their position.

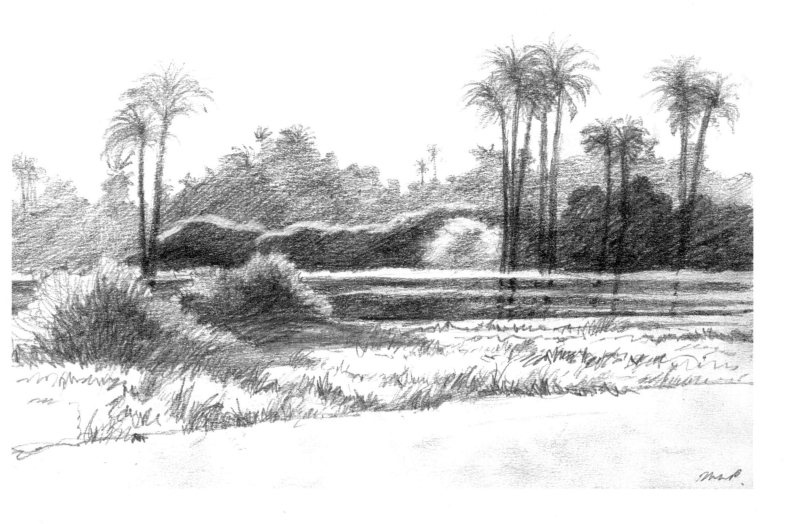

Colours

The colours you use for drawing trees and woodlands can vary enormously, not only from season to season but from week to week or even day to day. This is particularly the case in spring and autumn, when the processes of growth and decay are in full flow, but the effects of sunlight and cloud cover can also make an actual change in the colours present.

The colour swatches shown opposite and on page 93 are by no means intended to be a definitive selection of what I use, or what you should use – they merely indicate the range and type of colours used on the sketches they accompany (the names are generic). There is no clear cut-off point between the ranges, and one or two colours are used in all four pictures; if anything, this proves once again that there is no effective substitute for direct and accurate observation and experiment – remember the idea of making colour notes in your sketchbook (see page 33). *Continued on page 92*

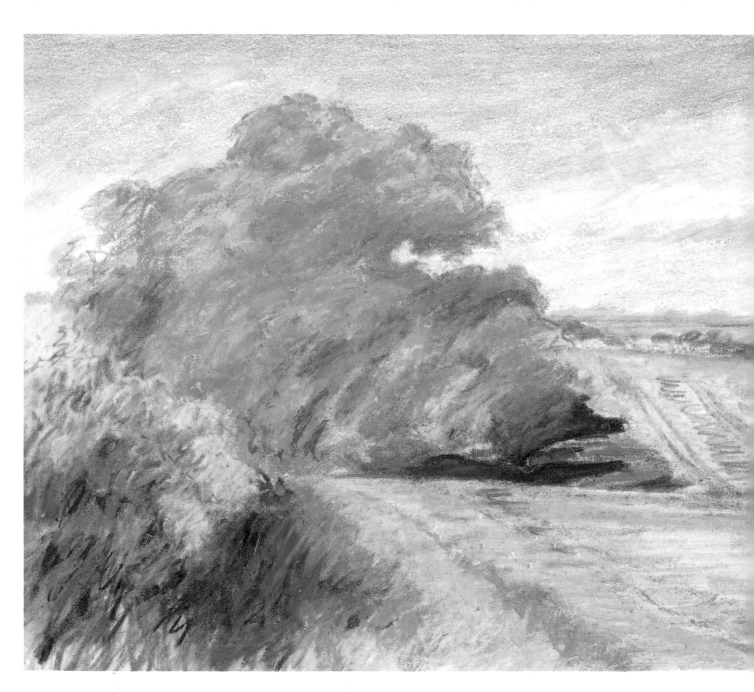

SPRING STUDY IN WATERCOLOUR PENCILS AND PASTELS The fresh, light green of the leaves and grass dominates the colour scheme, but note how much of the structure of the trees is still visible. The evergreen on the left keeps its darker colours through the year.

SUMMER STUDY IN WATERCOLOUR PENCILS, PASTELS AND OIL PASTELS All the colours in a summer scene are intensified in full sunlight – the lush greens of the leaves have a counterpoint in the warm colours of the field on the right. Here, there is a lot of yellow in the leaves.

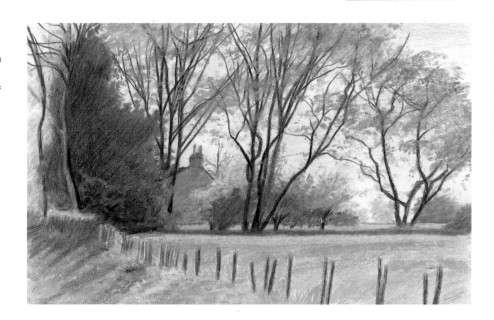

SPRING COLOURS Left to right, top row: Naples yellow, yellow-green, light green, grass green, olive green, cool green; middle row: jaune yellow, orange earth, orange-brown, orange, caput mortuum, dark green; bottom row: golden brown, yellow ochre, spring green, light blue, cobalt blue, kingfisher blue.

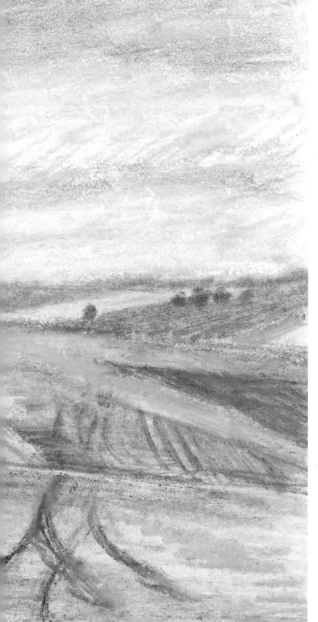

SUMMER COLOURS Left to right, top row: cadmium yellow deep, cadmium yellow medium, deep yellow, orange earth, rouge jaune, golden brown; second row: red-brown, caput mortuum, yellow ochre, mahogany, dark orange, warm pink; third row: spring green, grass green, emerald green, may green, cedar green, viridian; bottom row: cadmium green, turquoise blue, warm blue, cobalt blue, cerulean blue, ultramarine.

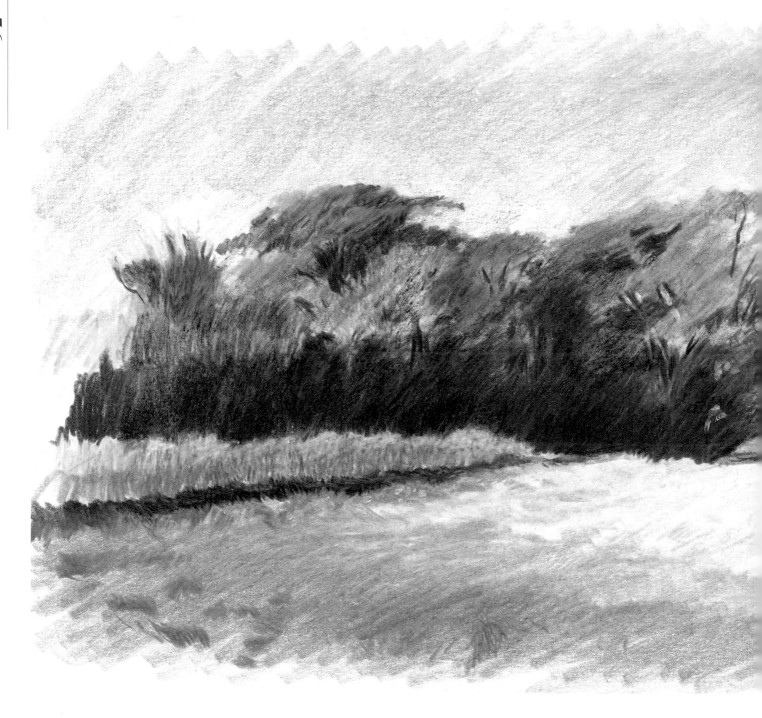

There are some 'rules' for tree and leaf colours that can be seen in operation through the passing of the seasons: spring colours tend to be quite bright and fresh, indicating growth; in summer the foliage is at its furthest growth, and the colours are likely to be rich and warm; autumn brings about both glorious bursts of every hue of red and yellow, and many shades of brown and russet as leaves start to die; and the more drab colours of the trunks and branches are all that can be seen of deciduous trees in winter, with evergreens providing the only relief – but again, don't assume that all trunks are the same colour, or that there are no variations within a single tree.

Unlike painters, who can mix their colours on a palette, drawing artists must choose their colours carefully and layer them to achieve a successful result. This is in many ways an advantage, as it forces you to look both at the colours of the foliage that catch the light and the colours of the trees behind in a creative, problem-solving way, with the possibilities of mixing media never far away.

Trees are wonderful subjects at all times of day and in all seasons, and should be seen as a challenge rather than as a difficulty, and the eighteenth-century painter John Opie gave the best advice to the question of how to mix colours: 'I mix them with my brains.'

AUTUMN STUDY IN WATERCOLOUR PENCILS The colours of the leaves are brighter than those of the summer scene on page 90, but the overall effect is darker, as browns and darker greens become more predominant. The small tree on the right has already shed its leaves.

AUTUMN COLOURS Left to right, top row: Naples yellow, orange earth, cadmium yellow, yellow ochre, burnt sienna light, mahogany; second row: rouge jaune, orange, cream brown, cadmium red, crimson lake, dark violet; third row: terracotta, dark orange, orange-red, may green, grass green, viridian; bottom row: dark green, olive green, cerulean blue, cobalt blue, spectrum blue, ultramarine.

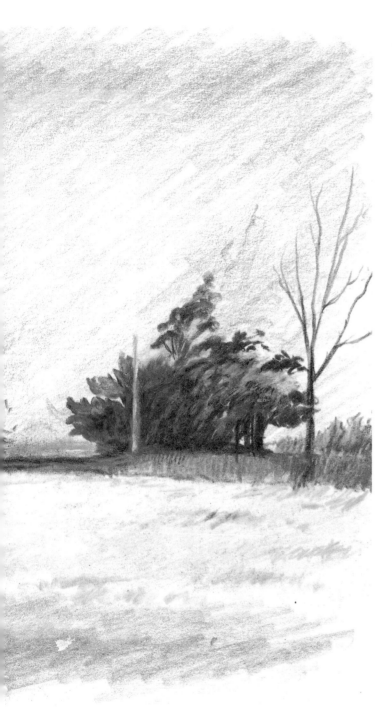

WINTER COLOURS Left to right, top row: Naples yellow, yellow ochre, orange earth, burnt sienna light, mahogany, mid brown; middle row: burnt umber, bronze, ice green, olive green, cedar green, burnt carmine; bottom row: dark green, viridian, light violet, ice blue, cerulean blue, cold pink.

WINTER STUDY IN WATERCOLOUR PENCILS, WAX CRAYONS AND OIL PASTELS On an overcast day, earth colours hold sway – the delicate tracery of branches and twigs is echoed in tone by the browns of the land, over-powering the still light green of the grassy areas.

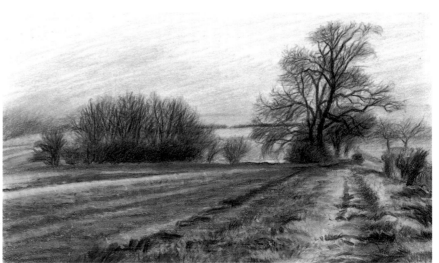

'*Perfect from a starting point, build, search, unite by lines, compare the big distances, the big strokes, harmonize… Drawing is everything; it is art in plenitude.*'

Jean-Auguste-Dominique Ingres (1780–1867)

Bringing
it all together

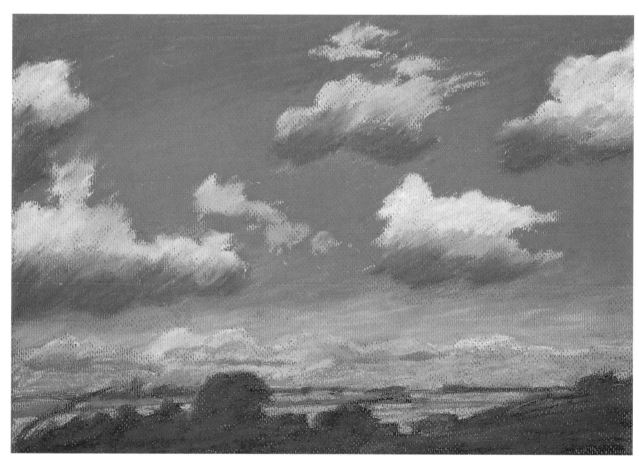

Project 1: Estuary in watercolour pencils

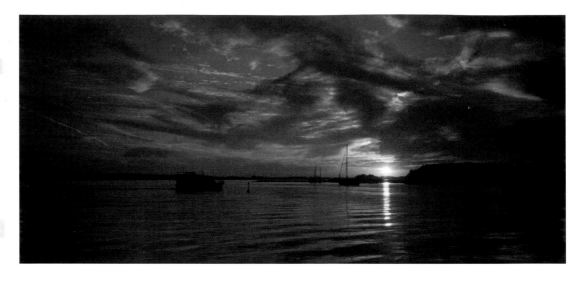

See also

Colours of skies
(pp. 46–47)

■

Reflections in water
(pp. 76–77)

YOU WILL NEED

Good-quality drawing
 paper

Watercolour pencils:

- *raw umber*
- *sepia*
- *ultramarine*
- *chocolate brown*
- *cadmium yellow*
- *orange chrome*
- *mineral green*
- *imperial purple*
- *red ochre*
- *straw yellow*
- *spectrum blue*
- *blue-grey*
- *brown ochre*
- *deep vermilion*
- *gunmetal grey*
- *Prussian blue*
- *white*
- *deep cadmium*
- *viridian*
- *brown chrome*
- *dark violet*

The chief attraction of this scene is the way in which the light from the sky is reflected in the water, demanding a different set of responses and drawing techniques.

The vertical shaft of sunlight is just about on an imaginary line known as the Golden Mean or the Rule of Thirds (see page 10), and I cropped the viewpoint for the drawing in from both left and right sides of the photograph, to emphasize this traditional composition aid. The cropping also has the effect of making the dark shapes that go right across the scene appear to balance each other more effectively.

Take time to choose your colour palette: with such a strong range in the original photograph, you can play down or emphasize the colours as you see fit.

REFERENCE PHOTOGRAPH The scene was shot on a wide-angle, panoramic format; however, there is nothing to say that you can't change this and concentrate on other areas than the whole scene.

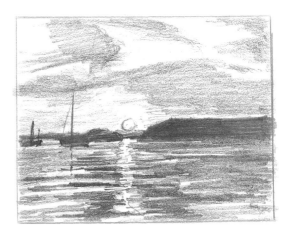

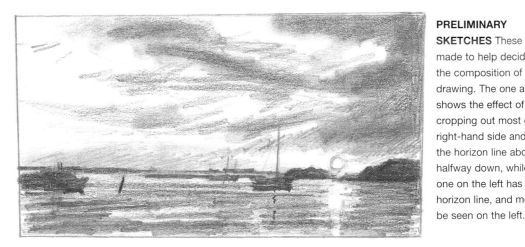

PRELIMINARY SKETCHES These were made to help decide on the composition of the drawing. The one above shows the effect of cropping out most of the right-hand side and having the horizon line about halfway down, while the one on the left has a lower horizon line, and more can be seen on the left.

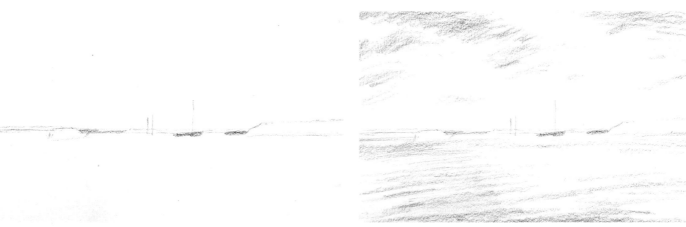

1 Start by mapping out the elements of the composition, using a raw umber and then a light sepia to block in the shapes. Adjust the shapes as required and then darken the ones that lie on the horizon line, which lies just below the halfway point from top to bottom.

2 Use the side of the ultramarine pencil to mark the main blue areas of the sky and the water, again working gently until you have established their positions. Don't apply any colour to the lightest areas yet, where the sunlight and its reflections are to be added later in the project.

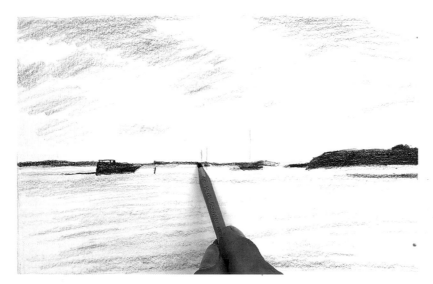

3 Block in the very dark shapes on the right using the sharp point of a chocolate brown pencil, then work across all the shapes on the horizon line. Bear in mind, however, that there is a lot of difference in the intensity of the shapes, and don't be tempted to add black for the darkest ones, as this will affect the tonal balance of colours.

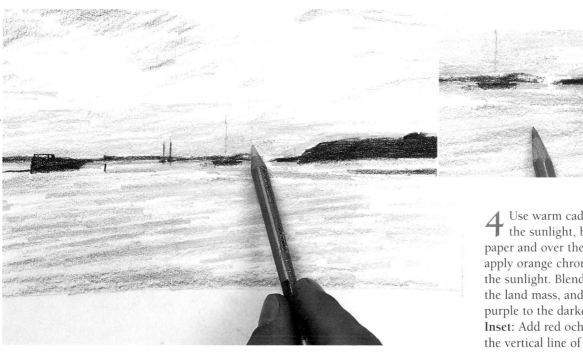

4 Use warm cadmium yellow to set the sunlight, both on the white paper and over the blue marks, then apply orange chrome to strengthen the sunlight. Blend mineral green on the land mass, and add imperial purple to the darkest areas.
Inset: Add red ochre on both sides of the vertical line of reflected sunlight.

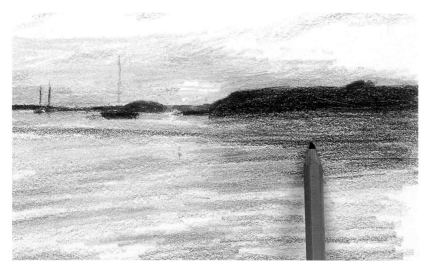

5 To intensify the colours of the sea, add first imperial purple and then light strokes of orange chrome, working along the ripples of the waves; apply ultramarine in the deepest blue areas and below the boat. Build up light applications of straw yellow on the sunlit parts on either side of the horizon line, filling in some – but not all – of the white areas on the sea. At all times look for the colour balance of the sky and sea to ensure that they work together.

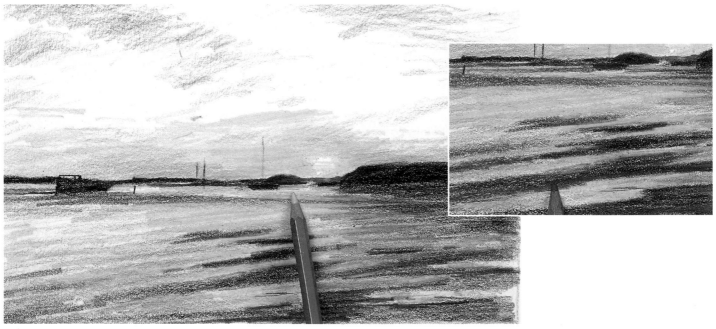

6 As you establish the areas of colour, you can now begin to push the pencils more into the paper, particularly when reapplying lighter colours, such as the straw yellow, over the darker ones. Add more imperial purple to warm up, as well as intensify, the waves on the lower right side of the drawing. Inset: So that the overall colour balance is not too warm, go over much of the purple with a layer of cooler ultramarine.

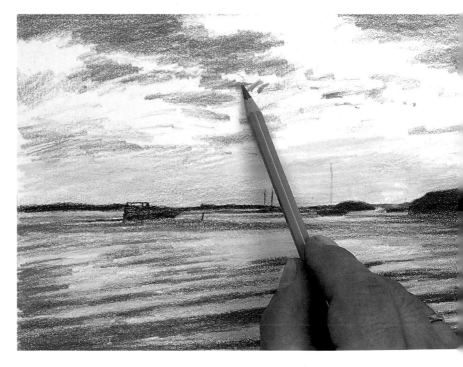

7 Follow the direction of the waves with a lighter spectrum blue, then go into the sky with this colour, working over what is already there and adding smaller touches to mark the edges of the cloud areas. Work lightly and freely, and go back and forth between the sky and sea – even though they are not mirror images of each other, this preserves the unity of the tones.

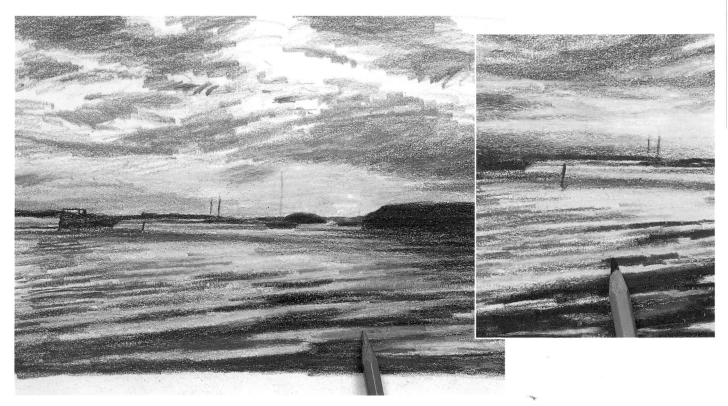

8 For the darker clouds, first apply an even covering of blue-grey, using pressure on the side of the pencil to make distinctions of tone, then add brown ochre to soften the edges where the yellow light meets them. Echo this in the sea area. Add orange chrome to the sunlit areas, and darken the horizontal land lines with purple, also using this colour opaque in the sea area. **Inset:** Strengthen the horizon with deep vermilion and add light touches to the waves, then intensify the cadmium yellow around them.

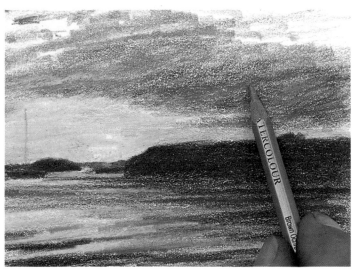

9 Tone down the darkest clouds with gunmetal grey, working over the spectrum blue across the picture. Switch to a deeper Prussian blue for the sky, and also use it to pick out the masts and vertical reflections. Work between these colours, drawing lightly to build up the tones.

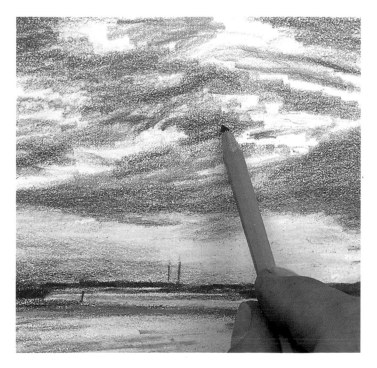

10 Work white pencil into the focal point of the sun, wetting the pencil to provide texture and to get away from the white paper effect. Use the white to calm the most intense oranges and reds, then use orange chrome around the vertical shaft of white light. Wet a deep cadmium tip and use it to reinforce the yellow reflections on the waves; use the same technique with purple, then add viridian green to intensify the sea colour. Gently deepen the sea and sky blues with spectrum blue, then go over parts of this with the blue-grey.

The darkest masses are drawn with colours only, not black

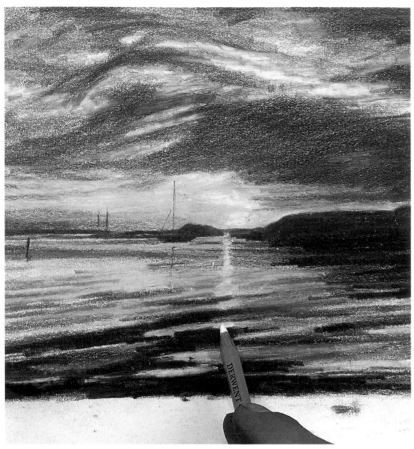

11 Use blue-grey to add a little more definition to the waves, then add brown chrome to knock back the intensity, primarily at the base of the picture, but look to see if this should be applied anywhere else. Add dark violet to tone down the purple if it is too prominent, then increase the strength of the lowering sky above the horizon line with more blue-grey. Wet the white pencil and emphasize the patches of white.

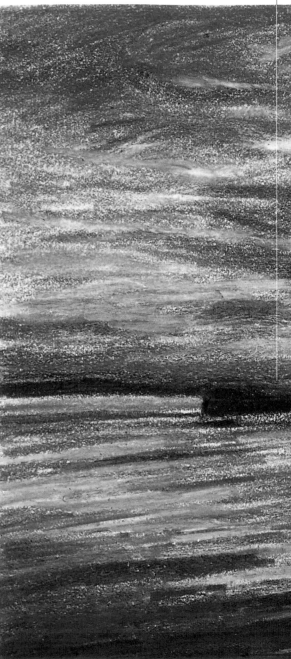

USING WATERCOLOUR PENCILS WET

■ *The watercolour (or aquarelle) coloured pencils used for this project are most often used dry, so that they can be blended or layered, allowing the layers underneath to show through in patches. If you wish to add solid blocks of colour, dip the tip of the pencil into clean water and drawing while it is still wet. Don't overwork the colour until it dries, but dip it frequently. For very small areas or lines, lick the pencil tip.*

Orange and ochre are used over pale and warm yellows

Areas of paper are left blank for the lightest colour of the clouds

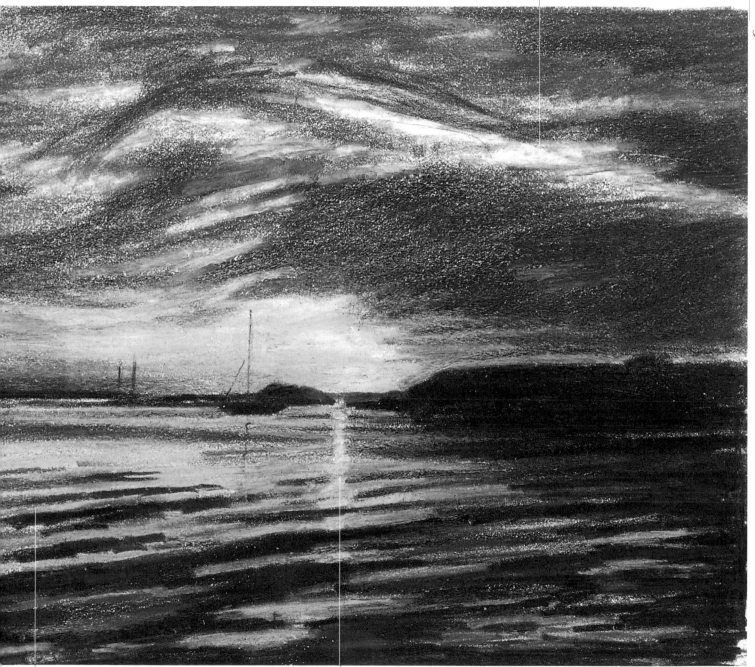

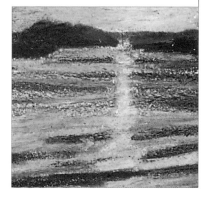

White pencil is used opaque for reflected line

INLAND SEA AND ESTUARY, HOLLAND

The colour blending and layering possible with watercolour pencils is the key to success in this picture, as you can achieve the variety of techniques relatively quickly through building up everything from wetted solid blocks of colour to broken-colour effects. The composition is an unusual one, with the main land mass and reflections, darkest clouds and shaft of white all on the right side of the drawing, but using all the colours over the whole picture brings a sense of unity and completeness.

Project 2: **Mountain in watercolour pencils**

See also

Choosing your viewpoint
(pp. 14–15)

■

Aerial recession
(pp. 56–57)

■

Still waters
(pp. 72–73)

YOU WILL NEED

Good-quality drawing
 paper
HB pencil
Watercolour pencils:
■ *gunmetal grey*
■ *may green*
■ *grass green*
■ *burnt sienna*
■ *cedar green*
■ *cerulean blue*
■ *blue-grey*
■ *light violet*
■ *mineral green*
■ *light ochre*
■ *red-ochre*
■ *olive green*
■ *white*

This project is all about aerial recession – the 'blueing', cold effect on faraway objects that is caused by the earth's atmosphere. Unlike many other landscape subjects, where there may be a gradual leading away to the furthest objects, the distance you have to go from mountains in order to capture the whole thing means that there may be a sudden change from the foreground to the recessive background.

I decided to use watercolour pencils for this scene as a contrast to the way they were used in the previous project (see pp. 96–101), and to show that the same medium can be used to depict quite different effects and atmospheres. Even with such muted shades, some relatively bright colours come into use.

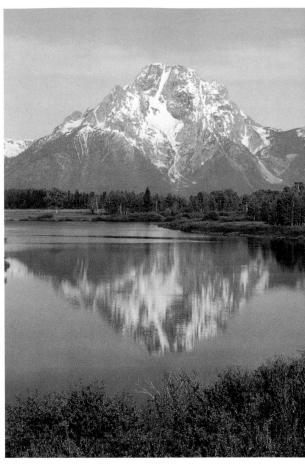

REFERENCE PHOTOGRAPH It was very tempting to include the stunning reflection of the whole mountain, but I decided that it, and the foliage in the foreground, were a distraction from the real focal point of the mountain and its shoreline. The foliage is, however, very useful as a reference point for the shoreline colours.

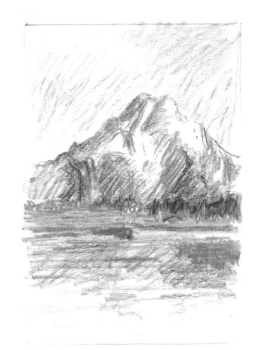

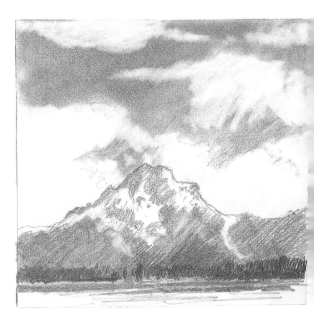

PRELIMINARY SKETCHES These sketches show phases in the planning for the final composition – the crayon sketch above was useful for setting the colour range and for thinking about which format to use. It includes part of the foreground water area and describes the reflections, though in a quite abstract way. The monochrome soft-pencil sketch on the right helped to set the tonal values, as well as trying out a landscape format and putting less water in the foreground. These two approaches were combined for the project drawing.

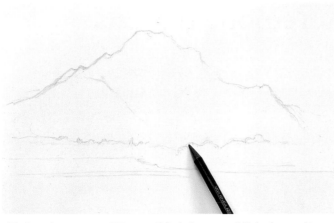

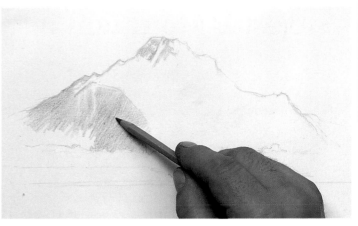

1 Start by using a HB pencil lightly to establish the outline of the peak and the foliage at its base. This sets the scale for the whole composition as well as finding the size of the drawing. Work down to the waterline, and be prepared to make amendments as you go along.

2 Lightly sketch in the areas of bare rock, using gunmetal grey. Use the side of the pencil for the larger areas, making short, directional marks, but be careful not to apply too much pressure – the overall effect is one of distance and recession, so keep the marks light.

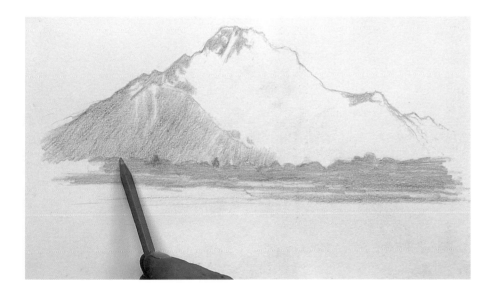

3 left As you block in the rock areas gently, make layers of pencil marks to suggest the different strata in the rocks. At the mountain's base, use may green to block in the strip of grass, and – paradoxically – grass green to start the colour and shape of the trees.

4 below Along the base, darken the treeline once it is established, then apply burnt sienna for the brown shoreline and cedar green for the darkest areas below the mountain. Build up the shoreline with these colours, then set the foreground water with cerulean blue.

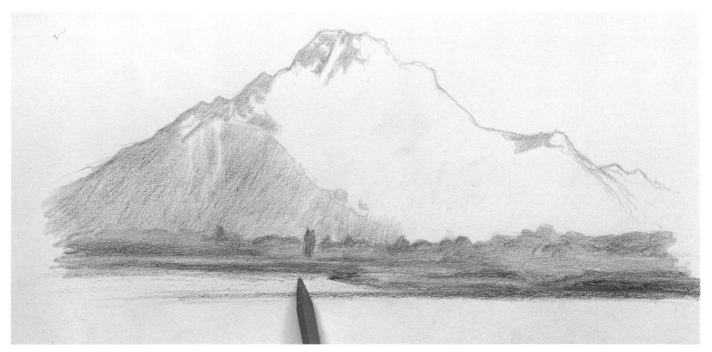

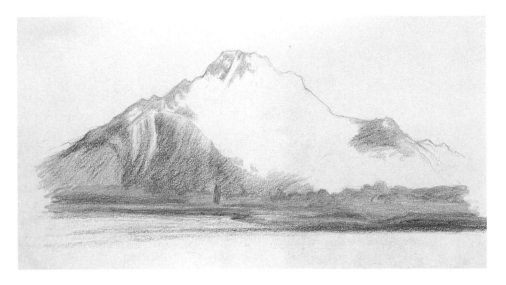

5 On the bare rock areas, apply a layer of blue-grey over the gunmetal grey – this will suggest cool temperatures in the darker rock areas as well as giving a sense of depth and recession. Alternate new layers of gunmetal and blue-grey across the whole mountain.

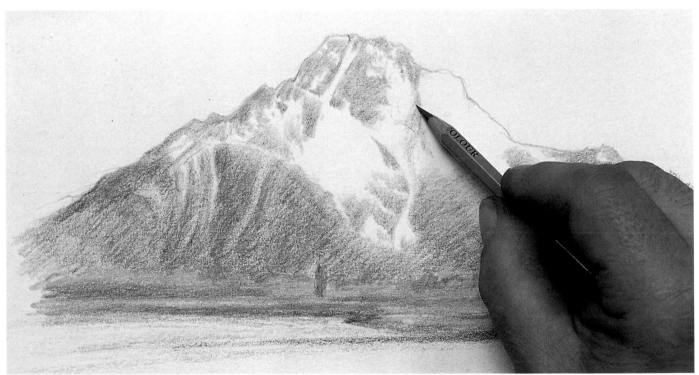

6 above Even at this stage, when the shapes and forms are settled, make no more than very light marks, building them up gradually. To counteract the masses of grey, introduce a little light violet, and then use all three colours to build up the rock areas, working in order: gunmetal grey, blue-grey, then light violet.

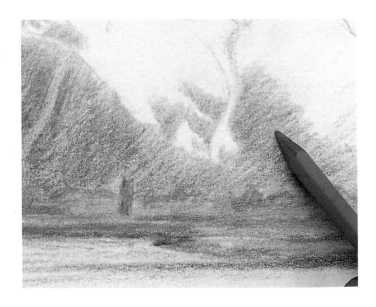

7 right Use single-direction hatching for all the colours and layers, both where the light hits the rock and the more 'hidden' areas – the further away the rocks, the lighter the hatching. By now you should be working around the negative spaces created by the patches of snow.

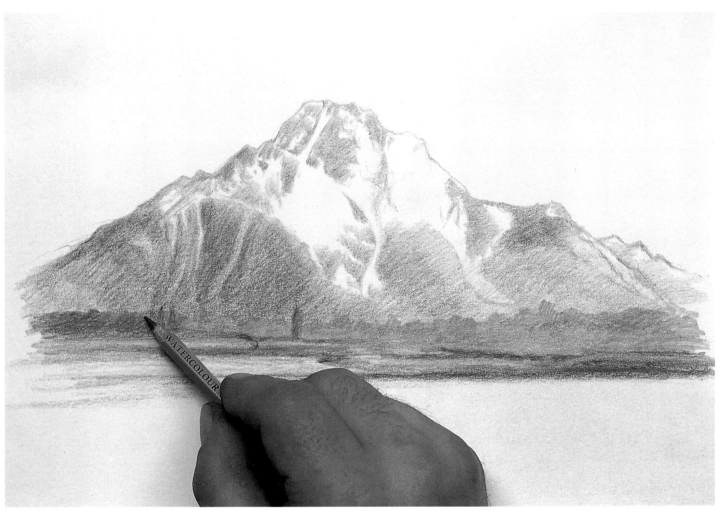

8 While concentrating on the areas of rock, look across the whole picture and check how the tonal values of the grass and trees below need to be amended. Use mineral green to enhance the colours across this lower strip, and to have the effect of increasing the impression of cold and distance.

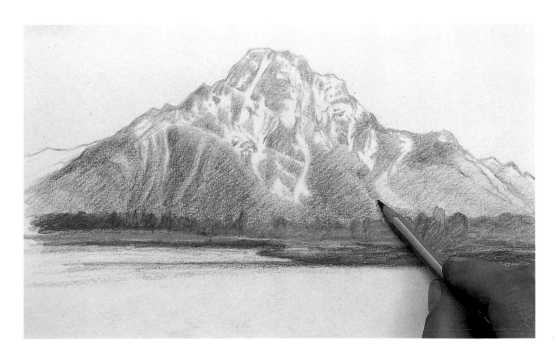

9 Boost the shoreline colours with light ochre and red-ochre, then go over the tree foliage and trunks with olive green. As you darken these areas, stand back and look at the mountain, and go back to the combination of colours used for the rocks, alternating this with the shoreline.

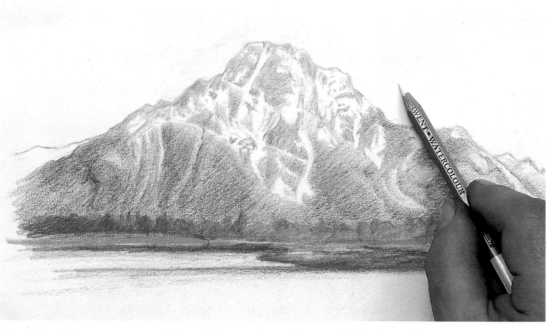

10 At this stage, start to redefine all the marks you have made for the rock areas, adding the finer details of the sheer faces, crevasses and so on. For the sky, start with a layer of white where the blue will be palest, before you apply any blue.

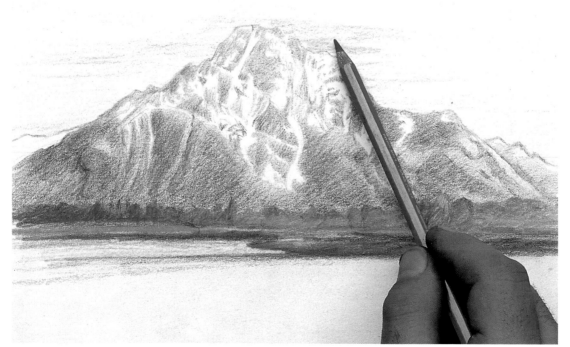

11 Using the side of the pencil and working gently, apply a layer of cerulean blue over the white underlayer in long, light strokes, blending the colours together. As you go above (beyond) the underlayer, the blue will darken, but continue to build up the colour in light layers, rather than pressing hard early on. Leave patches of white for the wispy clouds in the distance.

The strength of colour at the base contrasts with the rock just above it

The blue of the sky is no more than suggested

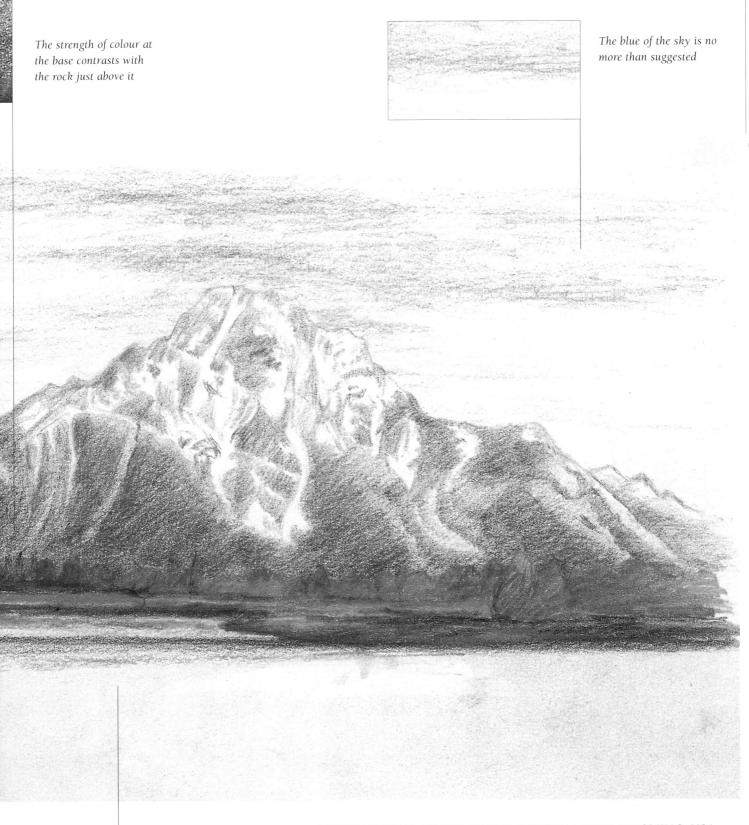

Leaving the bottom of the paper white can aid the sense of recession

MOUNT MORAN, GRAND TETON NATIONAL PARK, WYOMING, USA
When something is this far in the distance, yet still massive, the natural reaction is to put on too great a depth of colour, thus bringing the mountain closer to the viewer than it really is. The trick is to work very gradually and in lightly applied layers of colour – it may not be until the very final stages that the mountain tones take on any 'substance'. And although the overall effect of the rocks is cold, reinforced by the patches of snow, the bright sunlight adds a slight warmth, which must be included.

Project 3: Woodlands in charcoal

YOU WILL NEED

Yellow paper with
good tooth
Various widths of
willow charcoal
Torchon
Soft kneaded eraser,
cut into wedge
shapes

The low winter sunlight, slanting across a mixed deciduous wood, gave me the opportunity to contrast the vertical shapes of the trees with the horizontal cast shadows and the diagonals of the branches. There is a lot of movement in what is ostensibly a static scene.

Charcoal is a wonderful medium if you want to exploit extreme contrasts in tone and light quality, and the fine dust can be moved about easily with a torchon or your finger or hand. Because it is relatively inexpensive, you can buy a variety of widths and snap the sticks to give you a choice of lengths as well.

Some authorities and artists recommend the use of spray fixative at different stages of the drawing, so you can continue to work without the fear of smudging or losing what is already on the paper. My own working practice is to only use fixative when the drawing is finished – as you add shapes and tones, it is more than likely that these will affect all the areas of the drawing, and you will thus need to make adjustments right up to the last moments.

REFERENCE PHOTOGRAPH The slope of the ground is quite pronounced here; I slightly flattened it in sketches and the drawing to put more emphasis on the verticals.

PRELIMINARY SKETCHES The soft-pencil sketch below deals with the tone of the composition, while the pencil sketch on the right is a starting point in deciding what to leave out for the final composition.

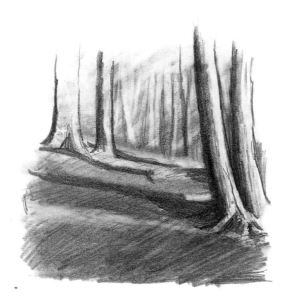

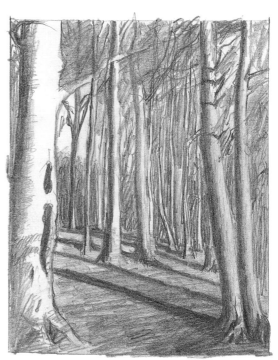

1 Use a thin charcoal stick to establish the trunk and branch of the foreground tree on the left. Make a few marks on the bark to introduce the darkest tones. Lightly sketch in the horizon line – this helps to set perspective and proportions, and can be erased later in the drawing process.

2 above Working back from the left-hand tree, move on to the next large one on its right. Check the angles of this tree and branches, then move on across the drawing. Even at this early stage, make sure you concentrate on the negative shapes as well as the positive ones – they help to set the angles and relationships of the branches across the picture.

3 left With these very first shapes established, add some of the smaller branches at the top, then move down to put in the roots and bases of the trunks. Use the side of a thick charcoal stick to gently introduce a little shading between the trees – this has the effect of setting the tonal values from which to work, and of throwing the trees into the foreground.

4 Use a thin stick to add some shading to the right-hand trees, then return to the left-hand ones with a thicker stick for more tonal shades, pressing harder into the tooth of the paper. Add the nearer trees in the middle, remembering that they will also be affected by the slanting light. With their branch angles established, block in the shading on the extreme right more heavily.

5 Add the furthest trees in the background, working carefully and using the negative spaces around and between the trees to get the proportions and relationships right. This is where you may have to make the decision to simplify what is in front of you, leaving out the trees that complicate or confuse the drawing, but retaining the impression of busy-ness.

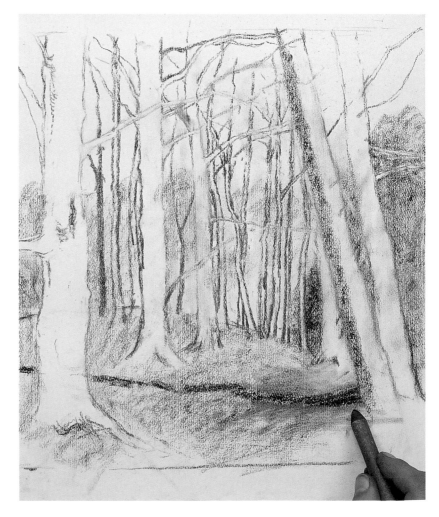

6 Continue to place the background trees, working across the whole drawing and standing back to get a better view of the whole – it is still easy to make amendments to the framework at this stage. Use a thick stick to block in the first horizontal shadow in the foreground, then blend and solidify the dust with a torchon.

7 Begin to block in the darkest areas on the right-hand trees with sticks, and use the torchon both to solidify the shadows and to push the dust across the trunks, thus grading the shadows back towards the light. Reinforce the torchon drawing with a thin charcoal stick, and use this and the torchon to add the first bark textures on the trunks.

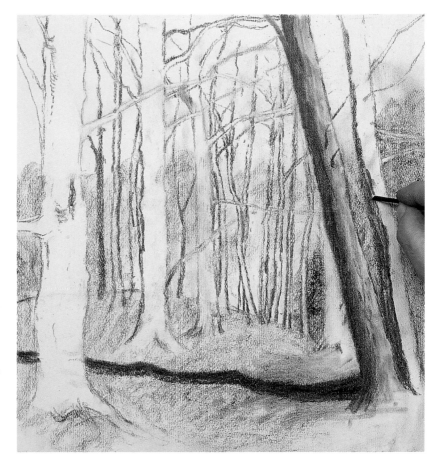

8 As you block in the blackest areas, check the tonal values of the lightest ones. Solidify the foreground with the torchon, then draw in further shadows along the ground, following the contours. Strengthen the outlines of the left-hand trees, and begin to put in the shadows on the trunk. Block in the foreground with the torchon, drawing light and shade and moving up the ground into the distance between the far trees, again paying attention to the contours.

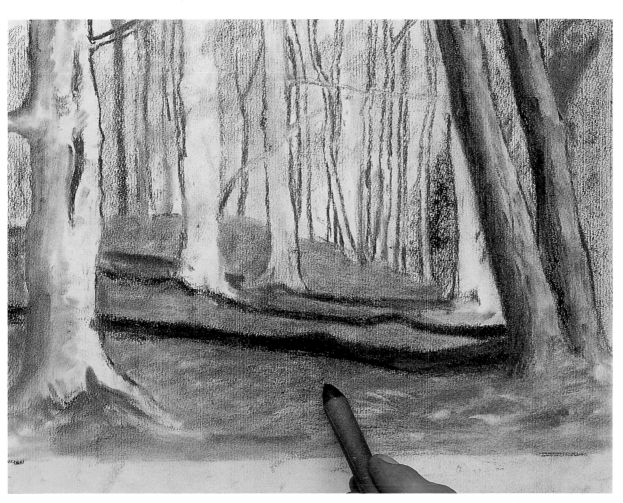

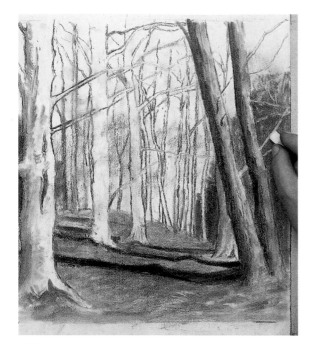

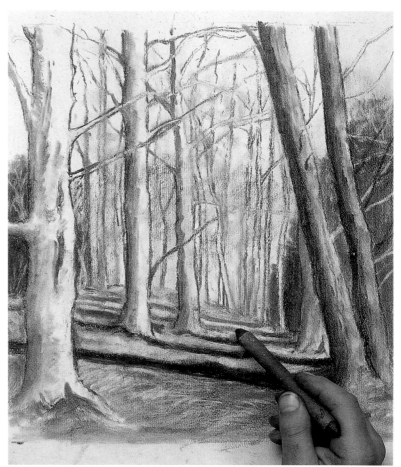

9 For the foliage beyond the woods, push the charcoal hard into the paper for a solid black, then move the dust around with the torchon. Add more bark textures, then cut a wedge of soft eraser and use this to draw the lightest branches against the dark areas of foliage.

10 above To increase the effects of contrast, add the darkest branches on the right, then move across the drawing, adding shadows to the trees and grading them with the torchon. Next, use the eraser wedge to lighten the ground between the cast shadows, adding directional contour marks as you do. Strengthen the cast shadows from the right-hand trees, looking at how they create their own horizontal pattern that has more regularity than the angles of the trees that cast them.

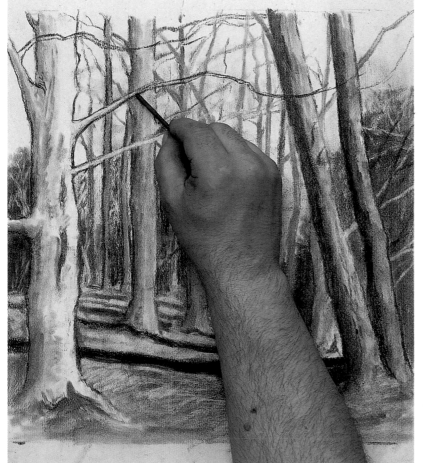

11 left Use the torchon to draw in the darkest lines of the trees in the distance, and then reinforce the lines with the thin stick – to avoid confusion, work downwards from the tops of the trees. At this stage, you should be adding the very darkest tones across the drawing, as well as using the eraser to pick out the lightest ones on the barks. Finish by adding the finer details of texture, and strengthening the thinnest lines of the branches.

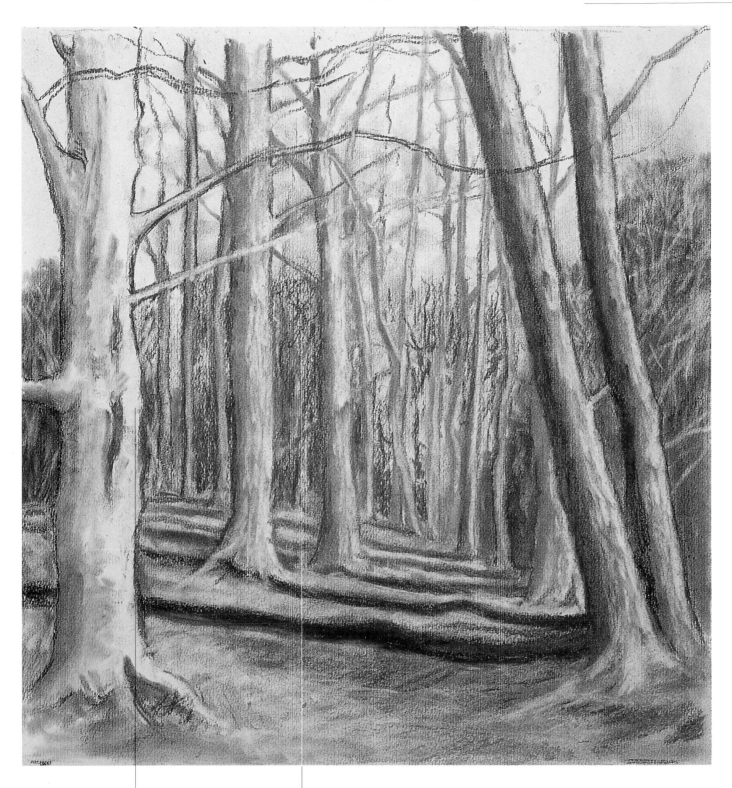

Highlights on the bark are picked out with an eraser wedge

Spiky marks in the background suggest more trees behind the main ones

WOODLAND AT TALKIN TARN, CUMBRIA, UK

Using a wood product to draw a woodland scene is satisfying in itself, and the texture of the toothed paper adds to the textures of the ground and the tree barks. There is an abstract quality to the finished drawing, with the angles and tones of the foreground trees and shadows setting up patterns without leading to a single focal point – this can be a risky undertaking, but the more time you spend learning to select a viewpoint and choose what to include and leave out, the better the end results will be.

Project 4: Water in crayons and oil pastels

See also

Aerial recession
(pp. 56–57)

■

Still waters
(pp. 72–73)

■

Masses of foliage
(pp. 86–87)

There are many scenes where a stretch of water is not the main feature or focal point of a drawing, but where it is a vital component that can make or break the picture as far as authentic representation goes. This is just one such scene – the water acts as the middle 'ground', keeping apart the foreground and background.

Ordinary wax crayons are often dismissed as nothing more than children's drawing tools, being too crude and unsubtle for anything approaching 'art'. For that very reason I chose

them as the basis of this project, and used a 'scholastic' set available from the local corner shop. The oil pastels, too, were definitely in the lower-price end of the market, but their buttery quality went onto the wax effectively.

One feature of such inexpensive materials is that the colours are most often not named on the packet or the crayons themselves; the names given here were laboriously arrived at after comparing each item in turn to more expensive watercolour pencils and soft pastels!

YOU WILL NEED

Warm off-white
 drawing paper
Soft kneaded eraser
Crayons:
■ *grey*
■ *blue-green*
■ *indigo*
■ *mineral green*
■ *yellow-green*
■ *dark blue*
■ *dark green*

Oil pastels:
■ *dark blue*
■ *dark turquoise*
■ *grass green*
■ *warm yellow*
■ *white*
■ *light orange*
■ *mid orange*

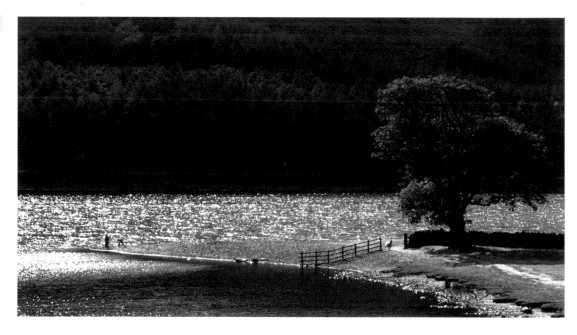

REFERENCE PHOTOGRAPH This shot shows the myriad of sparkling reflections on the water. The colour tones in the photo, however, have come out darker than the scene was in reality.

PRELIMINARY SKETCH Using wax crayons and oil pastels allows you to work freely and concentrate on the colour in the scene – you can tighten up in the final drawing if you like.

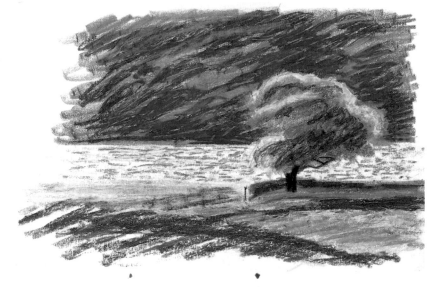

1 Use the tip of a grey crayon to make the basic shapes of the foreground tree, waterline, headland, background tree shadows and tree lines. Work tentatively and lightly, and use a soft kneaded eraser to make any necessary amendments.

2 above Using a blue-green crayon place the base of the background woodland and the water on the near side of the headland. Work lightly but confidently, covering the paper with long directional strokes. Draw the water around the headland with indigo crayon, leaving the tree and headland as negative shapes. Apply mineral green crayon to the headland and first line of trees.

3 right Lightly draw over all the woodland area with the mineral green crayon, allowing just a little of the blue underlayer to show through. Go over the foreground tree very lightly, and increase the pressure for its shadow. Apply a light layer of indigo over the headland.

4 Apply yellow-green crayon over the lighter parts of the headland. Next, go over the the indigo of the foreground water with a dark blue crayon – still searching for the tonal values rather than making a definitive statement at this point – and do the same on the hedge behind the foreground tree. **Inset:** Draw in the dark blue tones on the foreground tree, now working the crayon in quite hard to establish a solid block of colour and tone.

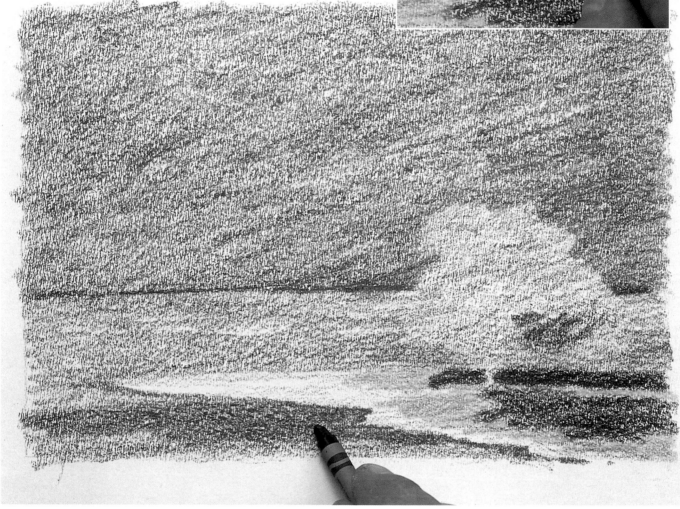

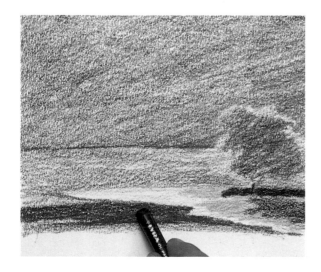

5 Pick out and model the shapes on the darkest part of the tree with the dark blue crayon. To reinforce the hedge, switch to dark blue oil pastel, which provides a more solid colour, but one that still allows the undercolours to show. Repeat this with the foreground water, grading the oil pastel over the crayon and leaving the underlayers to shine through as highlights on the water surface.

6 right Apply dark turquoise oil pastel over the woodland above the waterline, shaping the clumps of trees, over the tree shadow on the headland to give unity to the tones, and then back to the far trees, using directional strokes to suggest the growth. Go over the turquoise with dark blue oil pastel, again working directionally to darken the tones. Add grass green oil pastel over the waxy base for the brightest headland areas and the leaf outlines on the foreground tree.

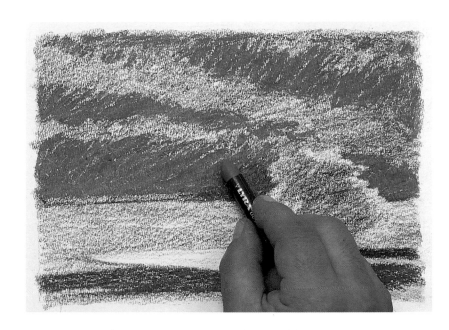

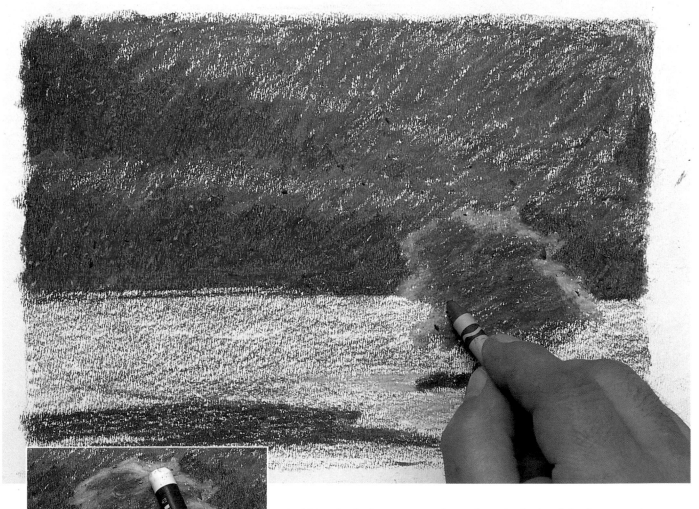

7 Use the dark turquoise oil pastel on the body of the foreground tree leafage, then work across the edges of the headland with the grey crayon. Use the dark green crayon to fill in the lightest parts of the background woodland area and to blend the various greens together; repeat this effect on the foreground tree. Then apply just a very light touch of warm yellow oil pastel over the brightest greens on the headland. **Inset:** Use white oil pastel over the lightest parts of the tree – the effect should be like shading, not solid, pure white.

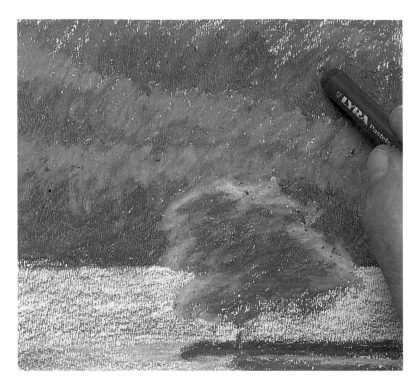

8 Use the white oil pastel as a blender between the layers of darker greens in the background woodland – both to soften the colours and make them appear cooler. This also creates light on the tops of the foliage. Repeat this across the entire background area before reinforcing the darkest background shades with the dark blue oil pastel.

9 Use the indigo crayon to make short, stabbing marks on the water surface, leaving sparkling highlights. Add some indigo over the headland green for unity in the picture. Reinforce the darkest blue of the shoreline with the dark blue oil pastel, then continue this using the dark blue crayon. Keep the tip of the crayon sharp as you work over the surface of the water, and build this area up gradually, ensuring that it is not too regular.

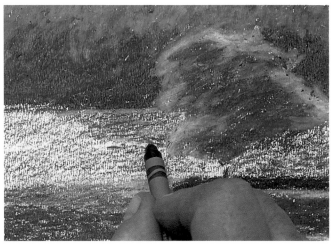

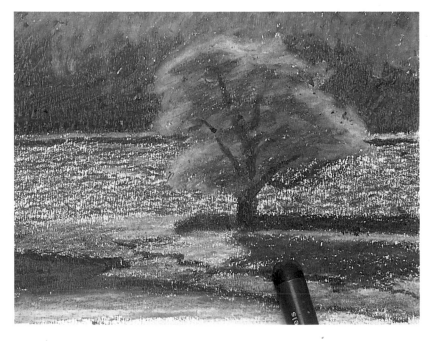

10 Use the dark blue oil pastel to intensify the background dark areas even further, particularly near the shoreline. Bring this colour into the nearest water and in the foreground tree foliage, then draw in the trunk and branches, plus the contours of the headland. Use indigo crayon on the headland to create blended shadow areas. As you work over the whole picture, strengthening the darker areas, add a little very light orange oil pastel to the headland and near water, then some mid orange oil pastel to the headland to warm it up and add colour.

Variations in tone and colour make up the 'even' surface of the calm water

The same blues and greens in the main tree unify it with the background masses

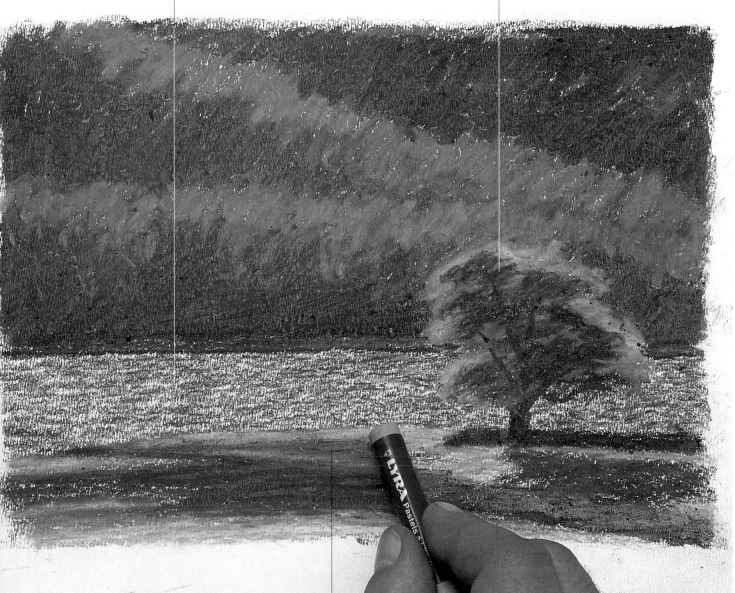

White oil pastel softens the darkest shades on the headland

BUTTERMERE, LAKE DISTRICT, UK

The challenge here was to capture the sparkling quality of the water, but to keep the sparkle within the bounds of reality – only the tops of the trees on the far bank receive any sunlight, with the rest remaining dark, while the main sunlit effect is on the tree and land in the foreground. Here, the combination of two waxy, oily mediums means that the depth of layered colour is in direct contrast to the shine of the sunlit water.

Project 5: Skyscape in pastels

See also
Clouds
(pp. 40–43)
■
Colours of skies
(pp 46–47)

YOU WILL NEED

Blue-tinted pastel
 paper
Torchon
Pastels:
- *Vandyke brown tint 8*
- *crimson lake tint 9*
- *burnt sienna tint 0*
- *burnt sienna tint 2*
- *blue-grey tint 4*
- *burnt sienna tint 4*
- *cobalt blue tint 0*
- *cobalt blue tint 2*
- *red-grey tint 6*
- *ultramarine tint 4*
- *ultramarine tint 3*
- *sap green tint 4*
- *raw sienna tint 4*
- *cadmium red tint 4*
- *yellow ochre tint 6*
- *red-grey tint 2*
- *white*
- *cool grey tint 6*
- *olive green tint 4*
- *Prussian blue tint 0*

This scene is characteristic of skyscapes on a hot, glorious summer day in the East of England, where I live. The flat horizon line is typical of the area, with only trees and hedges breaking it up, and the clouds have a seeming solidity about them, what children sometimes call 'castles in the air'.

In this kind of situation – where the clouds can alter position in the sky and the effects of light can change quickly, affecting both the cloud colours and those of the land – it is vital to get down as much reference material as you can: use photographs, sketches and written descriptions for this.

It is worth having a variety of pastel colours and shades for this project – as you work over the whole picture, the depth of colour on the ground and the undersides of the clouds needs to be checked and reinforced. In addition to using a torchon, you can blend the pastel dust with your finger, tissue paper or anything else that will do the job.

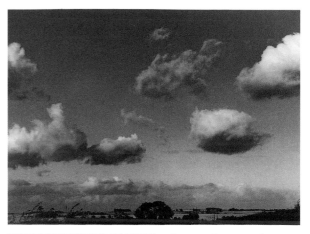

REFERENCE PHOTOGRAPH The photograph captured the basics – the cloud and sky colours, and the yellow of the cornfields. I cropped the view from the left to take the large tree away from the centre.

PRELIMINARY SKETCH This sketch shows more of the yellow foreground than the photo above. Using a fast medium such as pastels is invaluable in situations where the clouds may be moving across the sky quickly and the light quality is also changing rapidly.

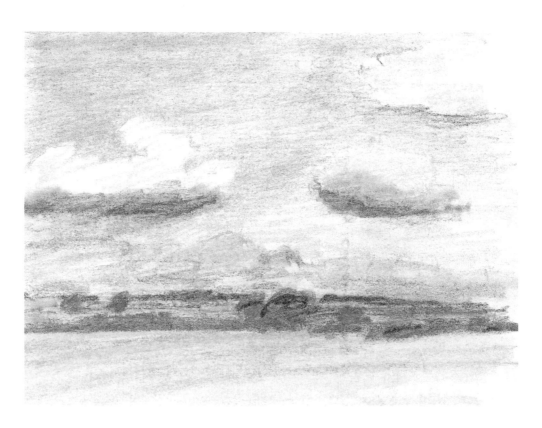

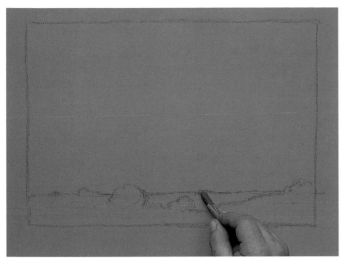

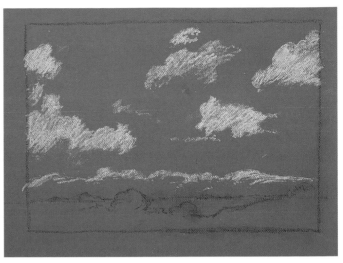

1 Use Vandyke brown tint 8 to sketch in the horizon line and the shapes on the land very lightly; this provides a context and framework against which the sizes, shapes and positions of the clouds can then be drawn. Make a variety of marks to fit the tree shapes into the line of the ground.

2 To establish the positions of the white parts of the clouds, use the tip and edge of crimson lake tint 9 – this provides a warm base for subsequent layers of pastel. Fill in the upper edge of the cloud bank on the horizon, then go over all the cloud shapes with burnt sienna tint 0 for more warmth.

3 To position the reflected tints from the land on the lower edge of the clouds, use burnt sienna tint 2. This warm colour also shows the glow of the sun. Work across all the clouds, and use this tint to indicate the amount of reflected shadow on each one, including the horizontal cloud bank nearest the land. Inset: Use your finger or a torchon to start blending the colours on the clouds.

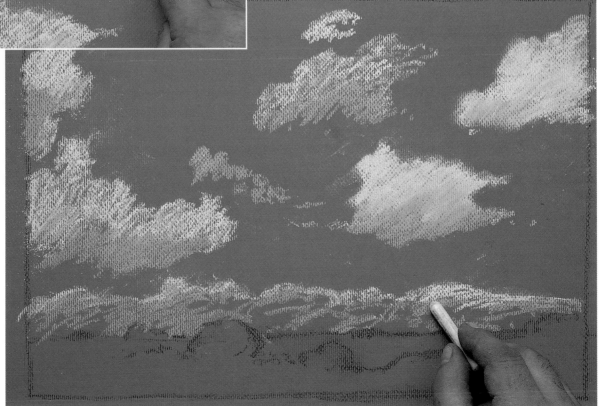

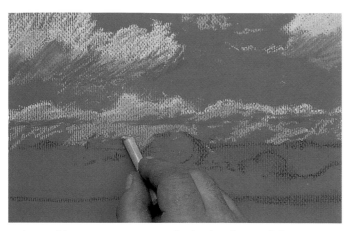

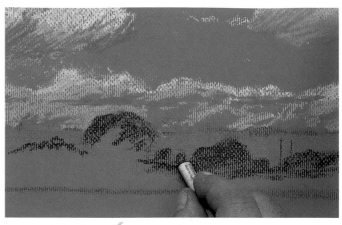

4 Use blue-grey tint 4 to apply the first layer of the grey on the base of the clouds, making sure that you follow the contours of each cloud with directional strokes. Once this tint is established, soften and blend the strokes, then add further layers and repeat the blending. Work in some horizontal strokes of the grey on the horizon cloud bank, using lighter applications of the pastel.

5 With the basic shapes and cloud tones in position, you can now begin to put some colours into the land. Block in the cornfield areas with a warm burnt sienna tint 4, applying pressure to achieve a strong effect. Next, solidify the tree shapes and 'silhouettes' using Vandyke brown tint 8, and introduce a few vertical shapes across the cornfield colour, to break up the horizontals.

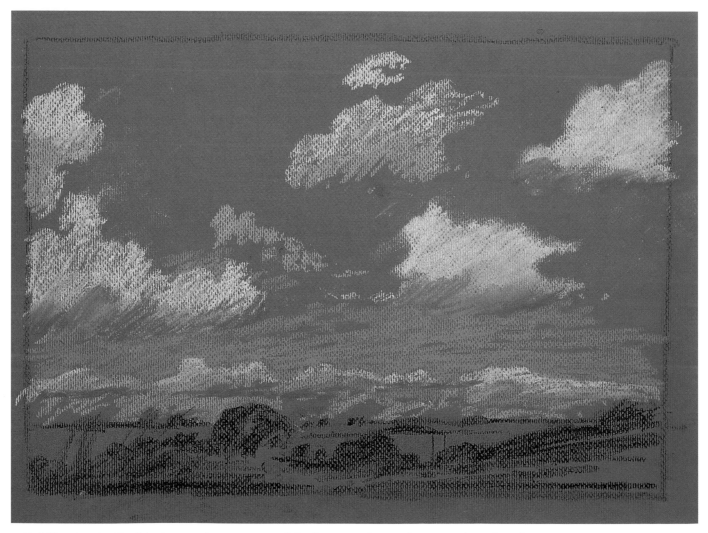

6 Still using the Vandyke brown, draw in some of the foreground grass shapes, working loosely and freely. Moving on to the sky, apply cobalt blue tint 0 for the lightest blue, nearest the horizon line. With this lightly in place, stand back and look over the whole picture to check that the tonal values are accurate throughout.

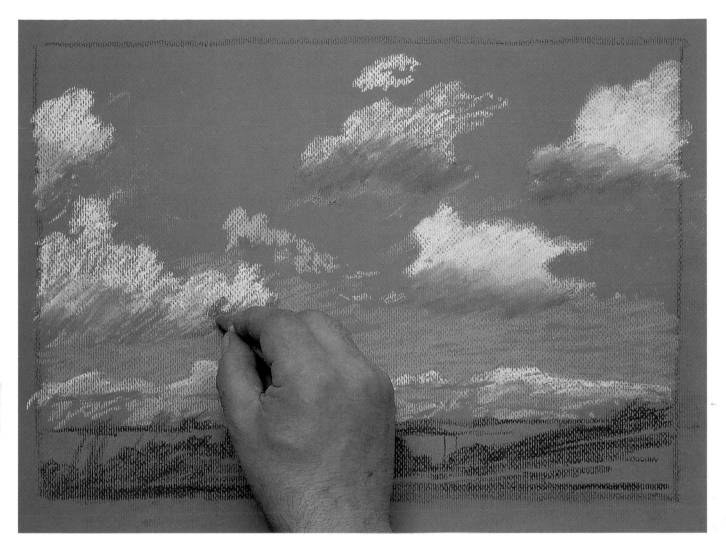

7 Use the cobalt blue tint 2 lightly on the undersides of the lightest clouds, working both in harmony with, and in contrast to, the blue-grey. Add a little red-grey tint 6 to these areas to warm them up, then blend the colours with a torchon or your finger. Soften the upper parts of the cloud undersides with the cobalt blue, and blend them again to merge the colours.

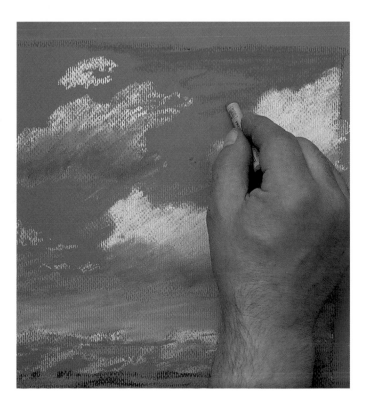

8 Start to reinforce the colours across the picture using more pressure and moving the pastel dust as required with the torchon. Use cobalt blue tint 0 for the light blue nearest the horizon, making hard strokes to indicate the directions of the clouds, then use ultramarine tint 4 to establish the darker blue at the top of the sky. Apply the same colour lightly across the very base of the undersides of the clouds.

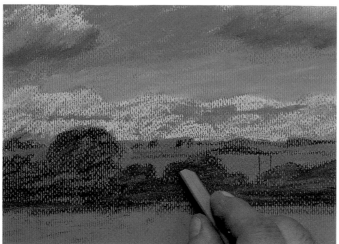

9 Use ultramarine tint 3 to establish the area in the middle of the sky, then fill in the lower cloud bank with burnt sienna tint 0, using this to shape as well as colour. Go over the foreground area (apart from the cornfield) and trees with sap green tint 4, blending over the brown; return to the brown each time before applying more green.

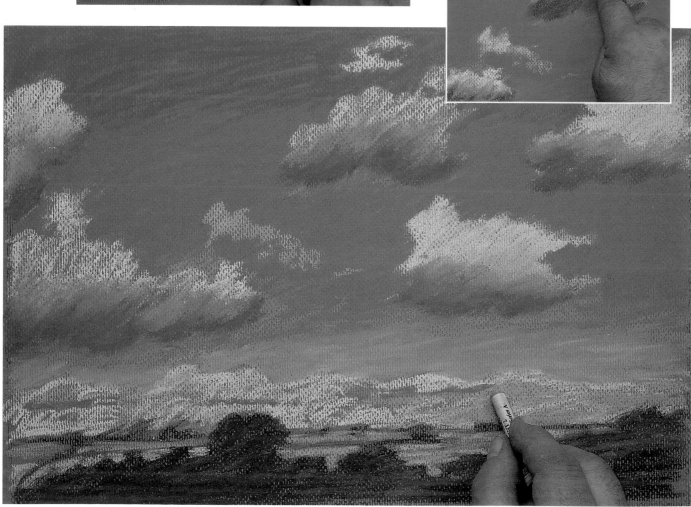

10 Warm up and brighten the cornfield areas with strokes of raw sienna tint 4, cadmium red tint 4 and yellow ochre tint 6; be careful not to overwork these layers, or you may lose the freshness of the pastels. Use red-grey tint 2 on the upper clouds for unity in the scene.
Inset: Blend in the edges on the clouds with your finger.

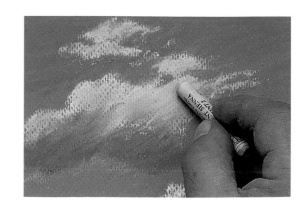

11 Only now add white, to bring out the highlights on all the clouds, blending as before. With these lightest areas in place, reinforce the ultramarine tint 3 across the undersides, then add burnt sienna tints 0 and 2 for the wispiest parts of the clouds. Look over the whole picture and strengthen and blend to give a sense of unity.

The warmest shadows are
midway up the larger clouds

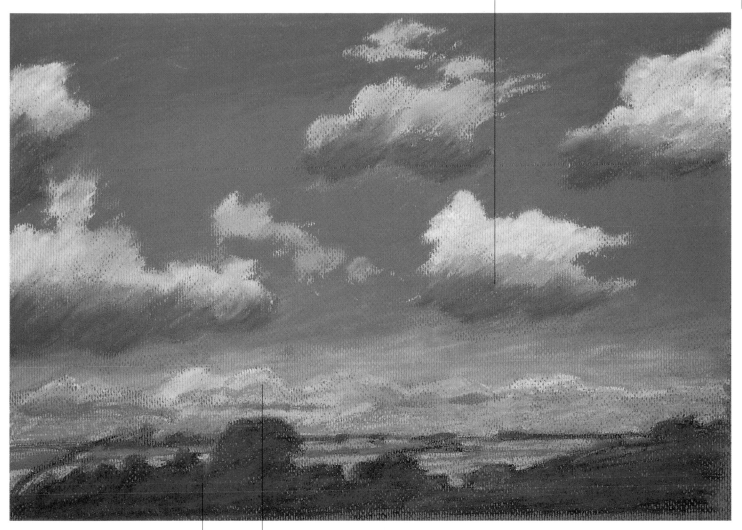

Olive green tint 4 and Prussian
blue tint 0 add brightness to the
foreground

Cobalt blue tint 2 cools down
the lower horizon clouds

CLOUDS AND LAND, LINCOLNSHIRE, UK

Pastels are an obvious choice for this landscape, as many dusty layers can be blended to produce the wispiness and subtle gradations of shadow colours on the clouds. One key to success is to apply and establish the warm colours on the cloud areas before adding white only in the latter stages, and solely to set the highlights – using white too early can introduce a starkness that puts the tonal balance out of adjustment and makes everything else seem darker than it really is. As always, it is essential to work across the whole picture as you bring in each new colour.

Index

illustrations *italic*

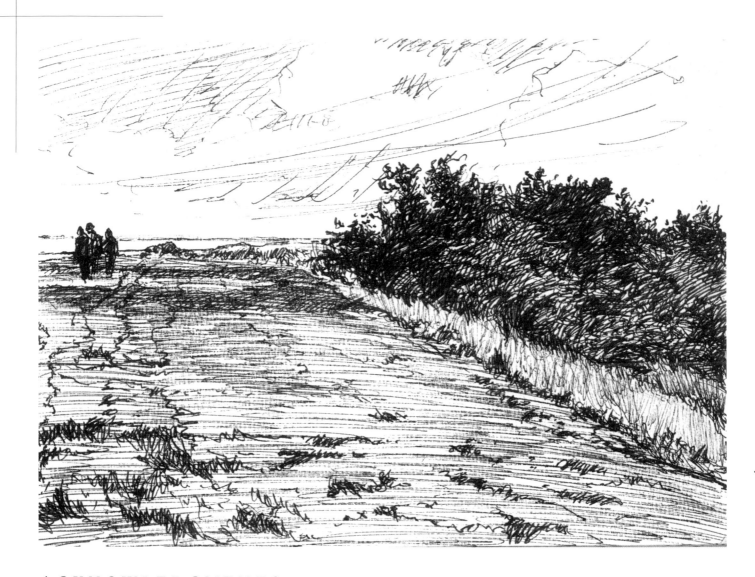

ACKNOWLEDGMENTS

I would like to thank Glynnis Petterson for all her
encouragement and enthusiasm; Sarah Hoggett for getting
this idea off the ground; Ian Kearey for his professionalism
and understanding; George Taylor and his assistant Sarah
Hickey for their patience when photographing my work;
and Sue Cleave and Freya Dangerfield for all their help and
expertise in making the book possible.

Melvyn Petterson

Freya Dangerfield and Sue Cleave; George Taylor and Sarah
Hickey for photo sessions; and Gemma Davies and
Caroline Halcrow for accommodation.

Ian Kearey